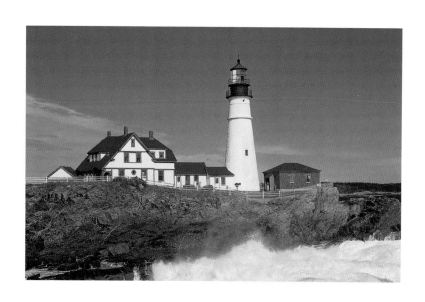

NEW ENGLAND

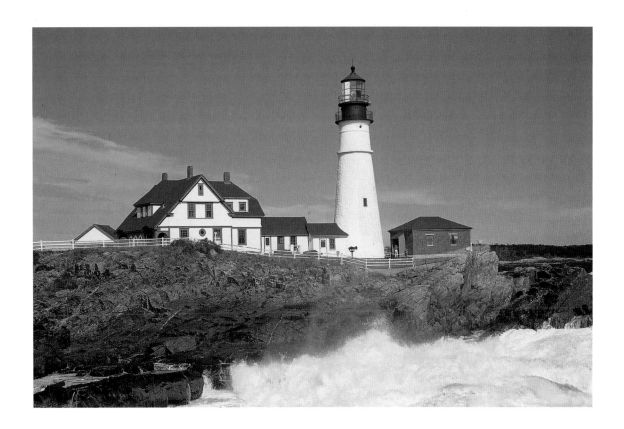

WHITECAP BOOKS

VANCOUVER / TORONTO / NEW YORK

The information in this book is true and complete to the best of our knowledge.
All recommendations are made without guarantee on the part of the author or
Whitecap Books Ltd. The author and publisher disclaim any liability in connec-
tion with the use of this information. For additional information please contact
Whitecap Books Ltd., 351 Lynn Avenue, North Vancouver, BC V7J 2C4.

Edited by Lisa Collins
Proofread by Elizabeth McLean
Text and photo editing by Tanya Lloyd
Cover and interior design by Steve Penner
Typeset by Tanya Lloyd

Printed and bound in Canada

Canadian Cataloguing in Publication Data

Lloyd, Tanya, 1973–
 New England

 ISBN 1-55110-947-6

 1. New England—Pictorial works. I. Title.
F5.L54 1999 974'.043'0222 C99-910830-1

The publisher acknowledges the support of the Canada Council and the
Cultural Services Branch of the Government of British Columbia in making this
publication possible. We acknowledge the financial support of the Government
of Canada through the Book Publishing Industry Development Program for our
publishing activities.

**For more information on the America series and other Whitecap Books
titles, please visit our web site at www.whitecap.ca.**

Wander down a lane in Vermont or stroll through one of Maine's coastal villages and you could easily find yourself swept back a century in time. The history that seemed staid and boring in your high-school textbooks suddenly springs to life, complete with daring heroes, traitorous villains, rebellions, and revolutions. A visitor to Plymouth, for example, might find pilgrims firing their muskets. A traveler in Providence might see the church of Roger Williams, who founded the Baptist denomination here after the Puritans banished him for his "dangerous" ideas.

And if it feels like you're walking in the footsteps of Mark Twain as you explore Connecticut's streets, you could be. Both Twain and Harriet Beecher Stowe, author of *Uncle Tom's Cabin,* were once residents of Hartford. Literature and art lovers can peek into Thoreau's cabin on Walden Pond, view Archibald M. Willard's famous painting *The Spirit of '76* in Marblehead, or stop at the House of Seven Gables, which inspired Nathaniel Hawthorne.

If you're more interested in the attractions of today than those of yesterday, enjoy the Faneuil Hall Marketplace in Boston, ski the steep slopes of Mount Mansfield, or celebrate the Pumpkin Festival with the thousands of revelers in Keene. You can stroll the trails of Acadia National Park, sail across the pale, early morning waters of Lake Champlain, or let a gondola sweep you to the summit of Mount Washington.

But as you enjoy these sights, keep in mind that behind the lighthouses, harbors, and maple trees that tempt so many people to tour New England each year, there lies a rich and varied past. Soon, you may find yourself speaking of characters such as Paul Revere, Alexander Graham Bell, and Elihu Yale as if you were once the best of friends.

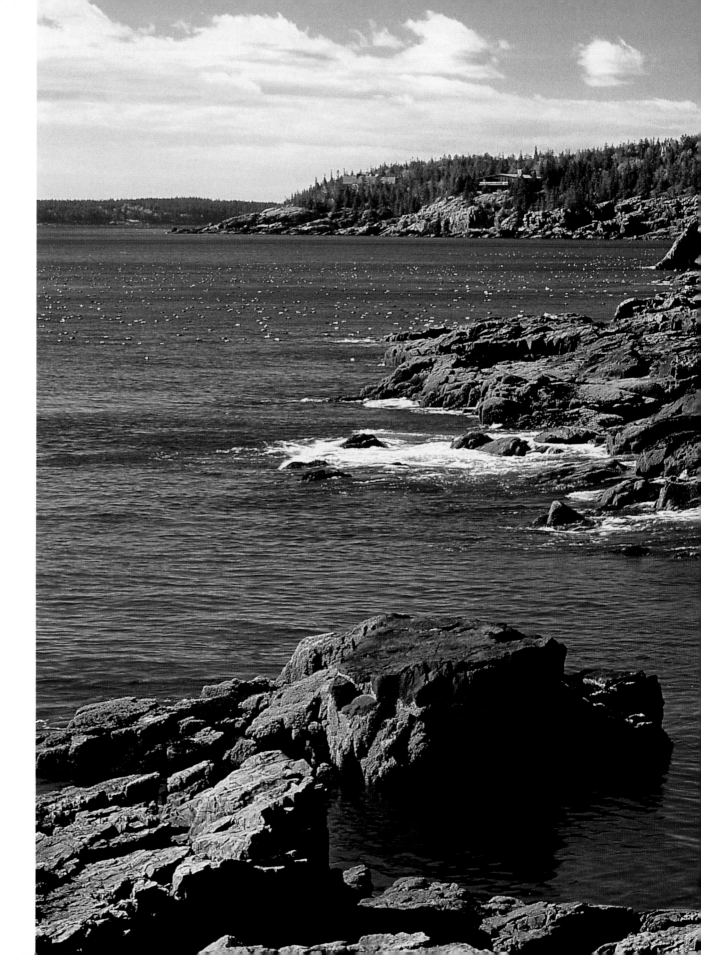

Acadia National Park
encompasses 35,000
acres, ranging from
rocky seashores to
mountain passes.
The preserve was
founded in 1913,
when President
Wilson set aside
6,000 acres. More
than one million
people now visit
the park each year.

6

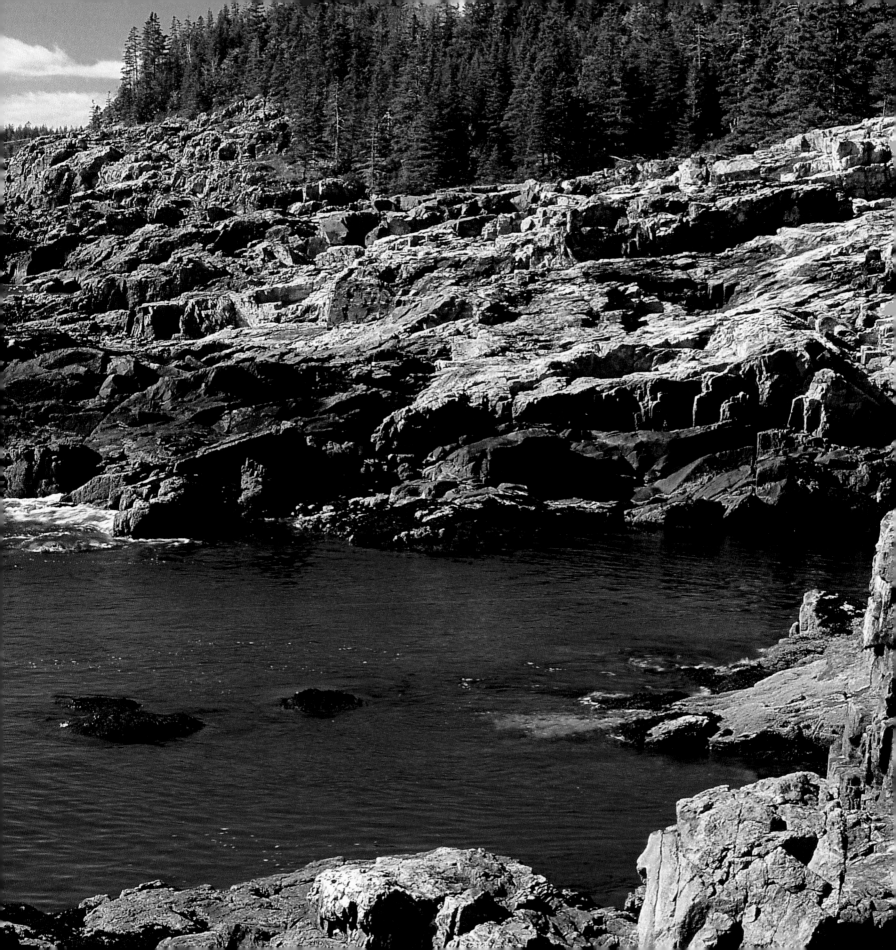

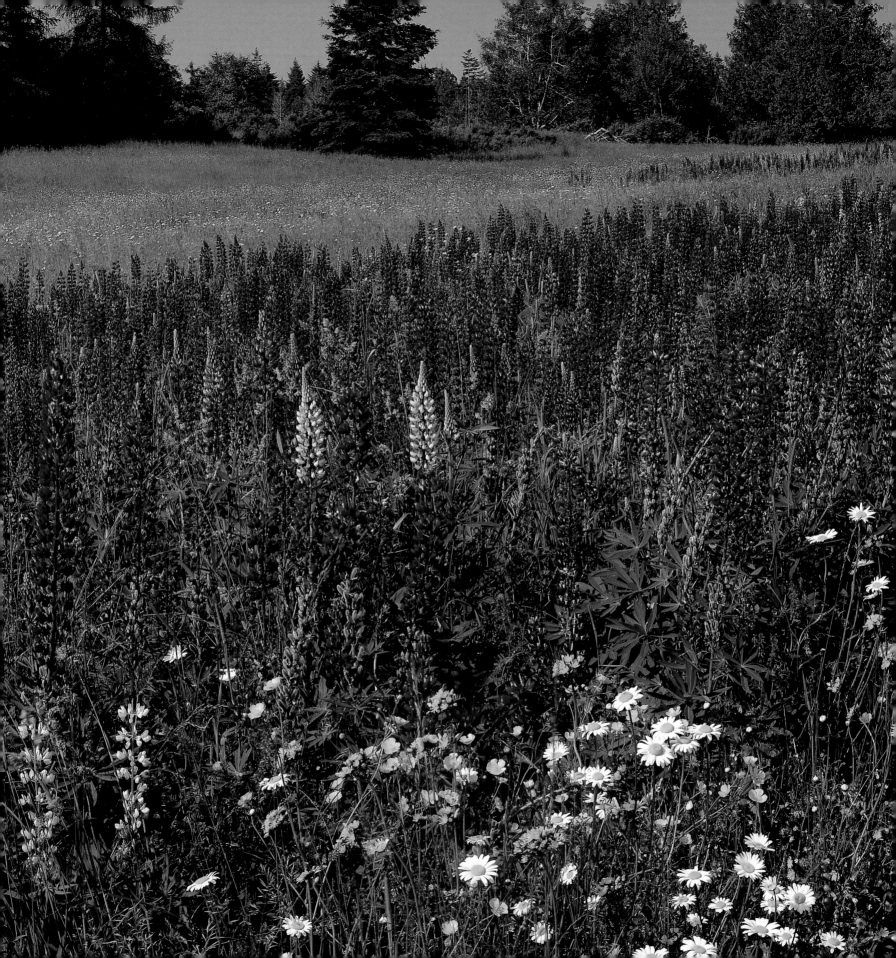

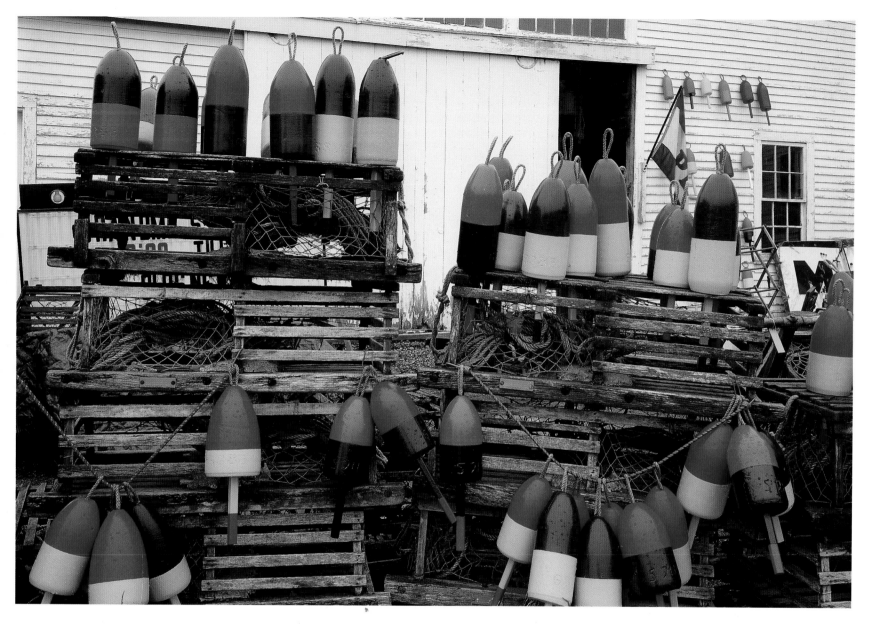

Most commercial fishers have traded their old lobster traps for wire ones. The wooden traps have become sought-after souvenirs of Maine's coast.

More than 120 miles of hiking trails allow visitors to explore the rugged terrain of Acadia National Park. Carriage roads, closed to vehicle traffic, also grant back-country access to mountain bikers.

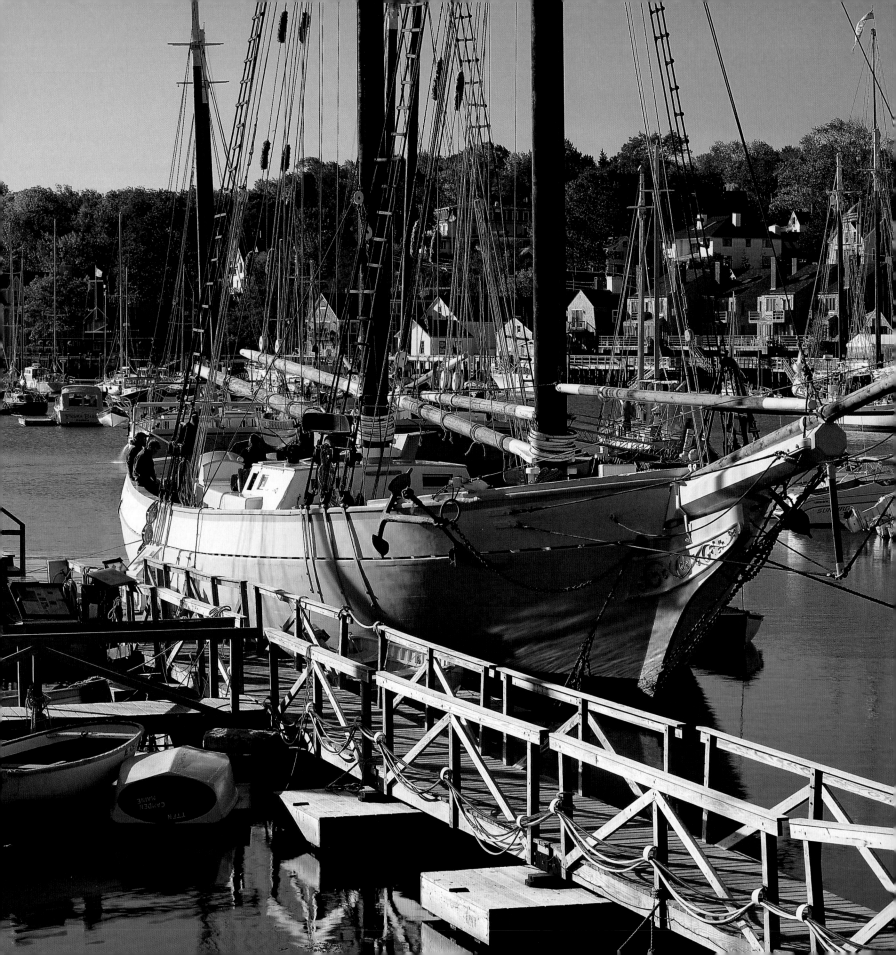

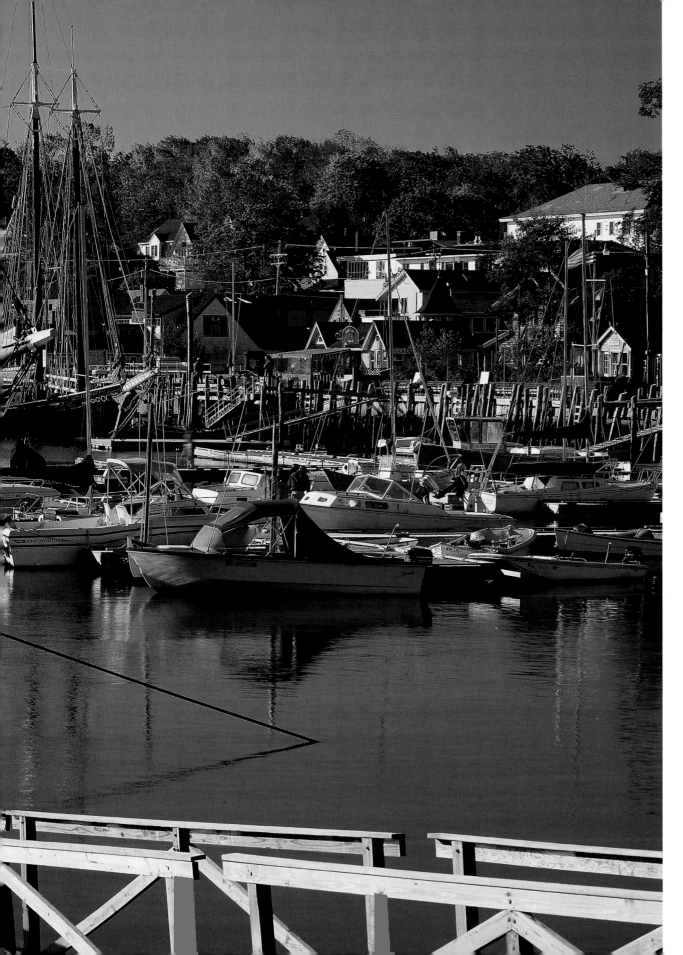

A wooden walkway leads to the *Mary Day*, docked in Camden's harbor. While the town's shops and inns draw thousands of tourists, the harbor is a familiar port to sailors all along the Atlantic coast.

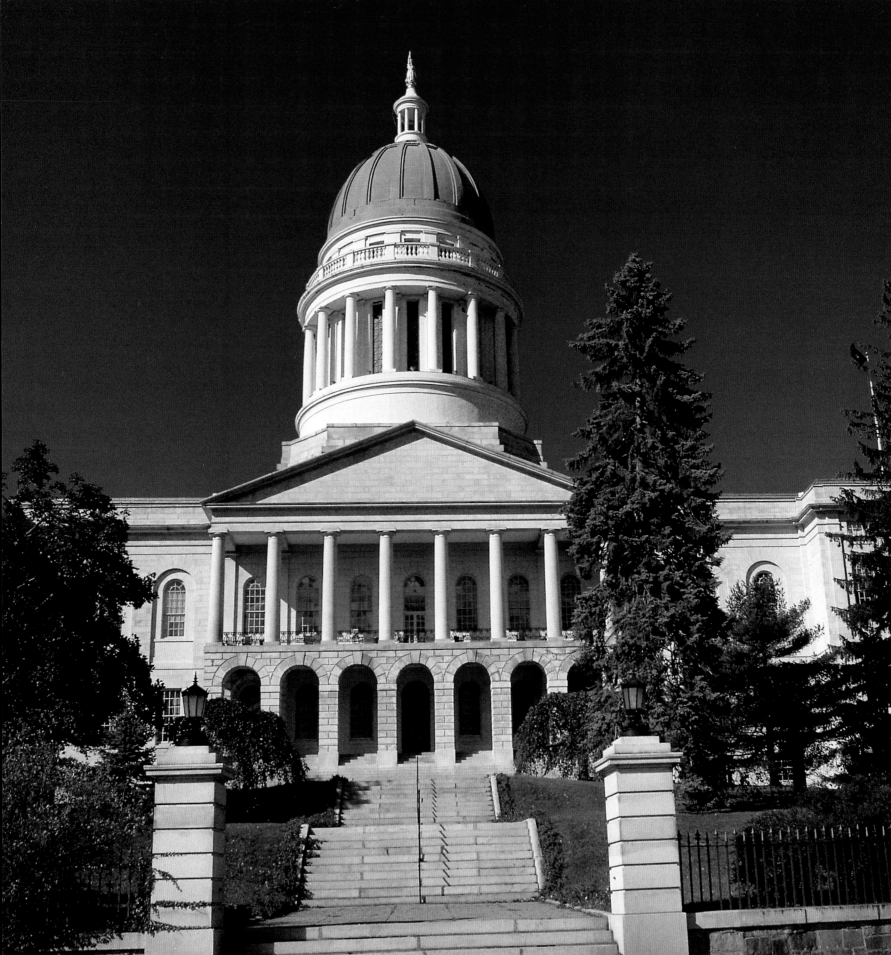

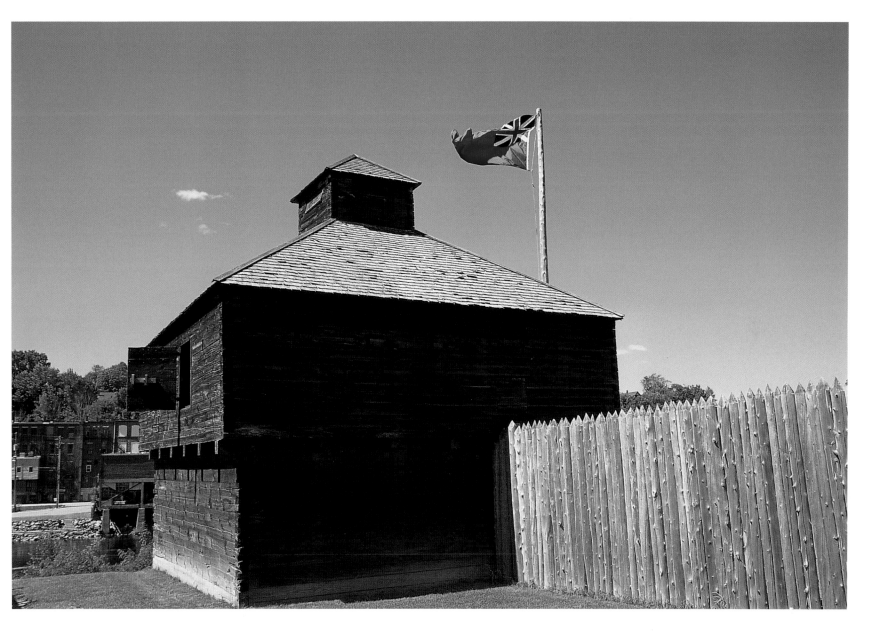

The oldest wooden fort in New England, Fort Western was built in 1754. The bastion was an essential defense post on the Kennebec River and a launching point for Benedict Arnold's forces during the American Revolution.

Augusta is both the capital of Maine and the seat of Kennebec County. More than 20,000 people live in the city, which spreads along the banks of the Kennebec River.

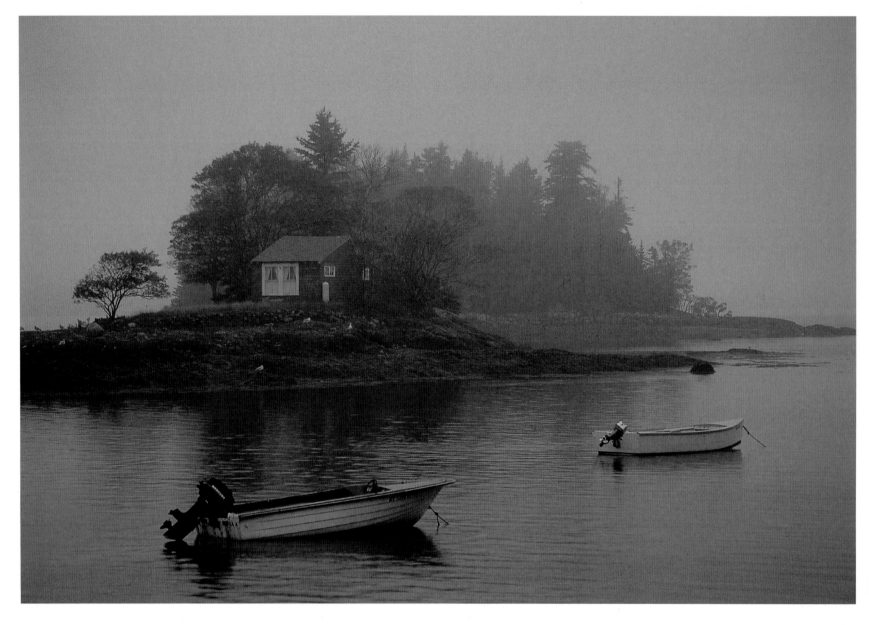

With hundreds of coves, promontories, and offshore
islands, the Maine coast is an astounding 3,478 miles long.

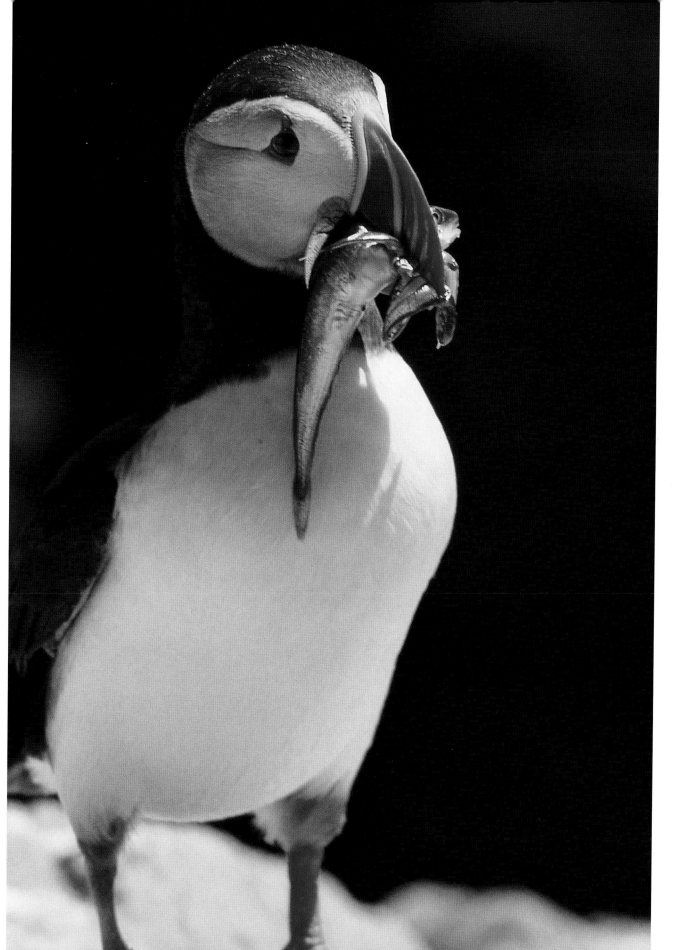

Lined with hooks, the puffin's bill is uniquely suited to scooping up herring. These birds have been known to carry up to 60 small fish at once.

15

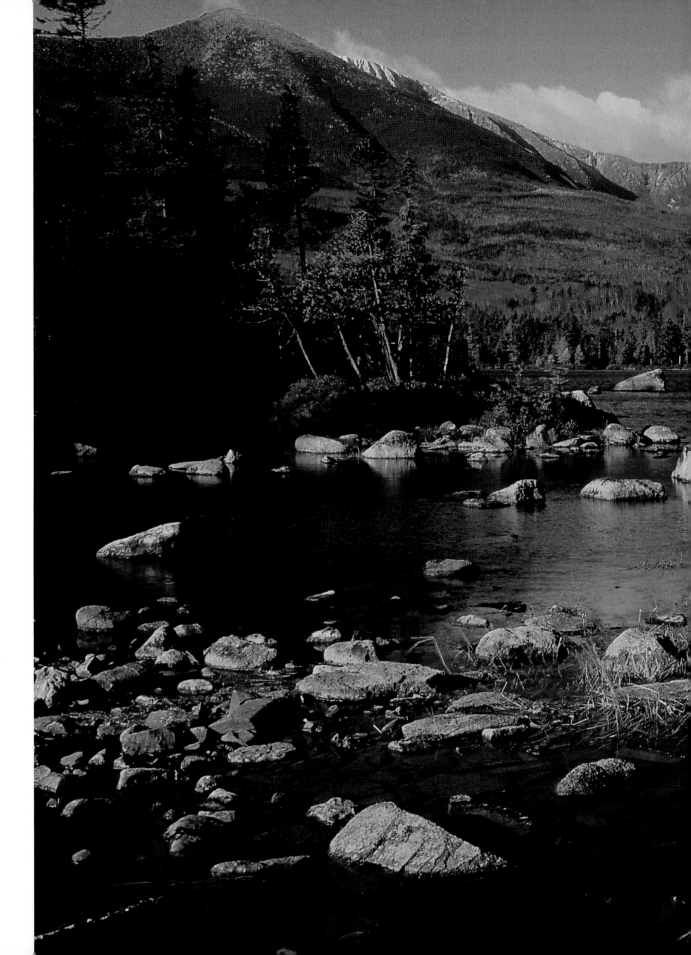

A favorite destination for campers, hikers, and rock climbers, 205,000-acre Baxter State Park was a gift to Maine from Governor Percival Baxter, who bought the land in 1931.

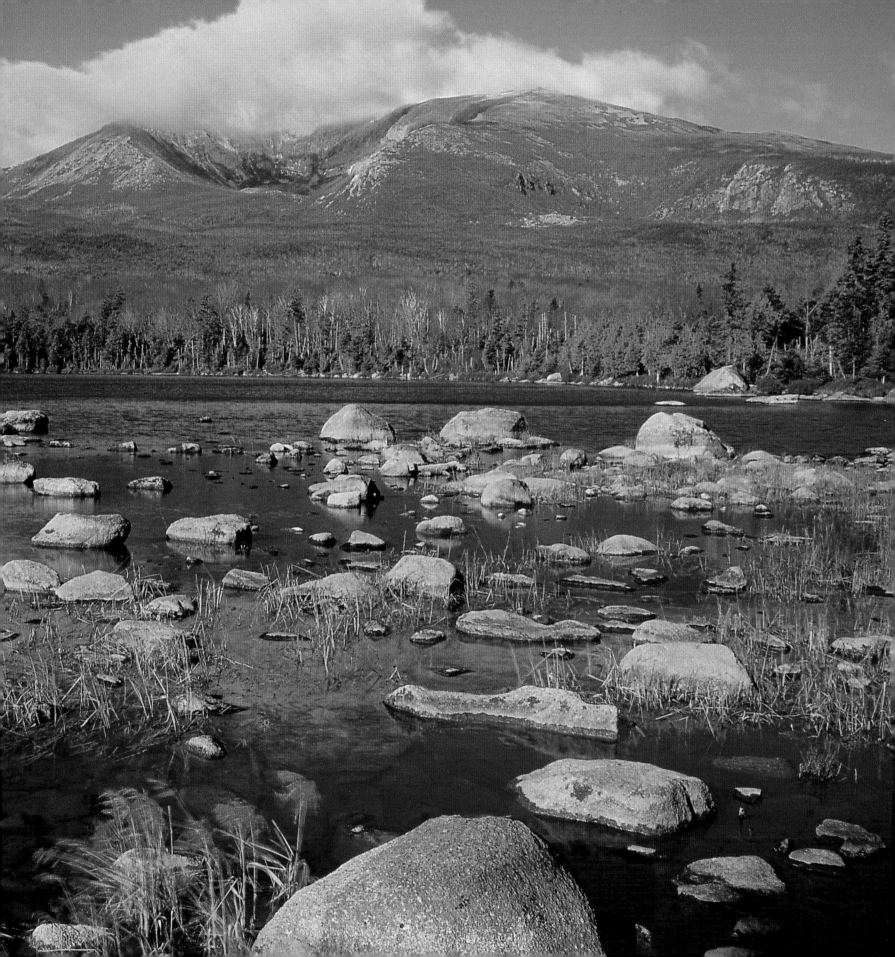

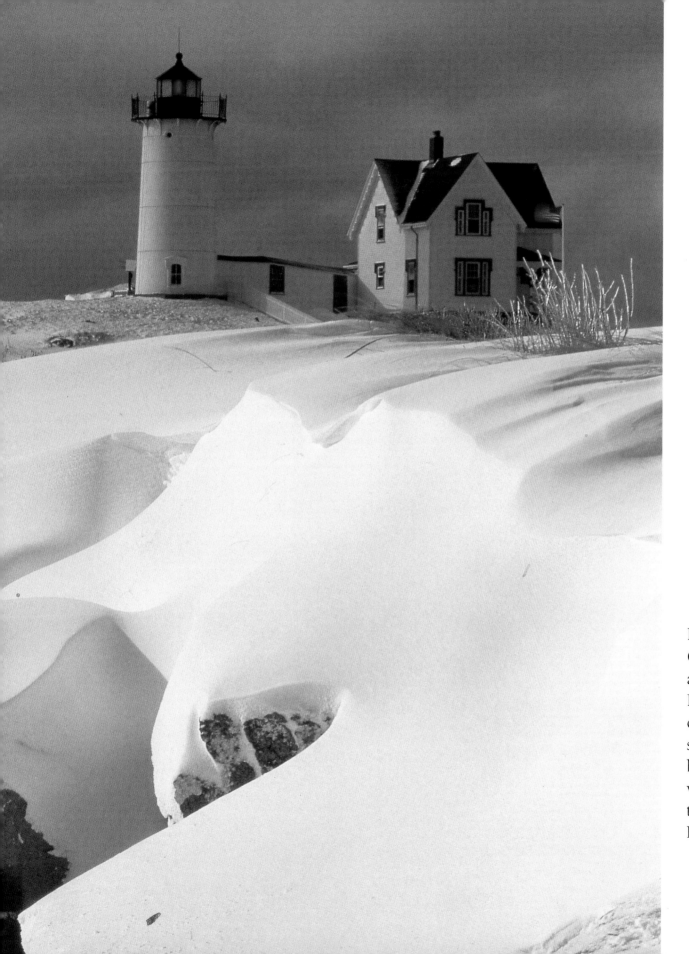

Established in 1879, Cape Neddick Light—also known as Nubble Light for its position on a rocky "nubble"—stands next to a clapboard house and white picket fence typical of New England's beacons.

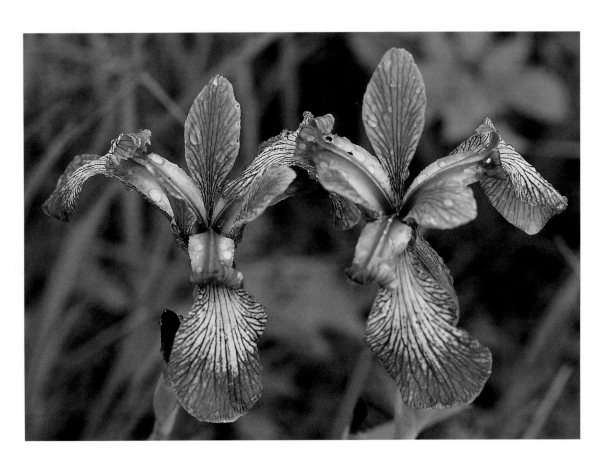

This blooming blue flag is one of more than 2,000 flowering plants and ferns that thrive in mountain meadows and under the canopy of New England's forests.

The winds that sweep the summit of New Hampshire's Mount Washington can reach over 200 miles per hour. The peak is part of White Mountain National Forest, the largest expanse of public land in New England.

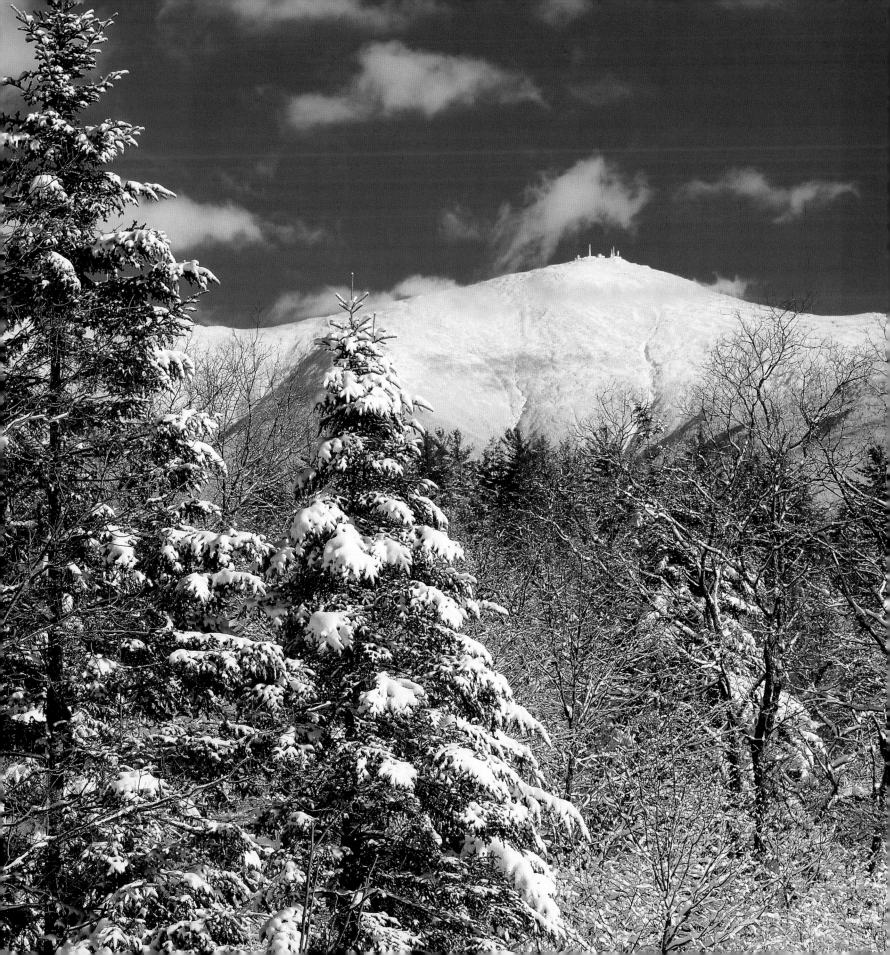

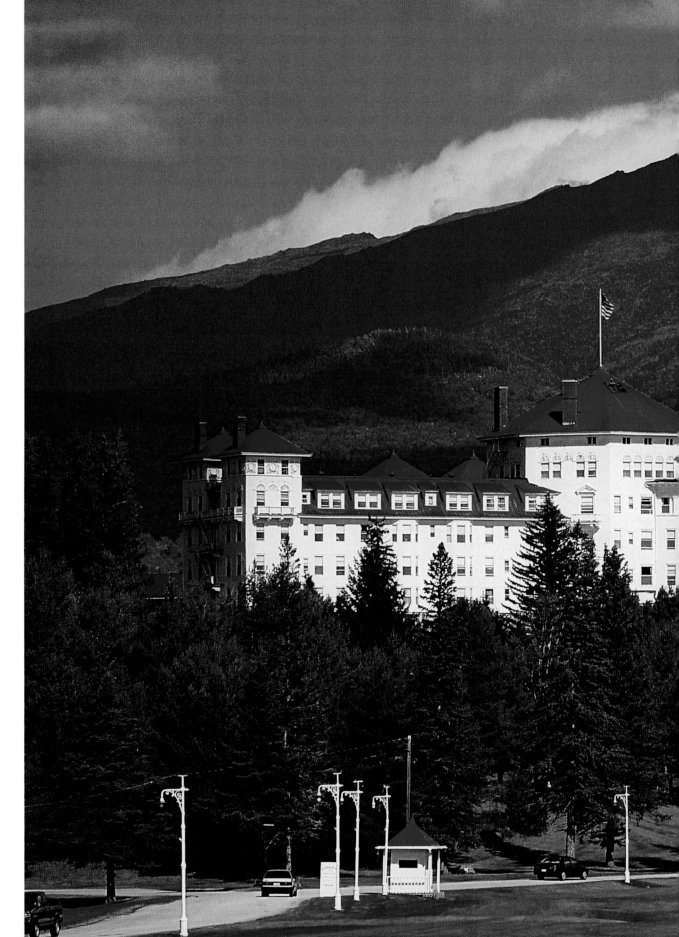

The deluxe Mount Washington Hotel and Resort opened its doors in 1902 and has been a New Hampshire landmark ever since. Visitors can enjoy the mountain air from the 900-foot-long verandah or tour the lush grounds in a horse-drawn carriage.

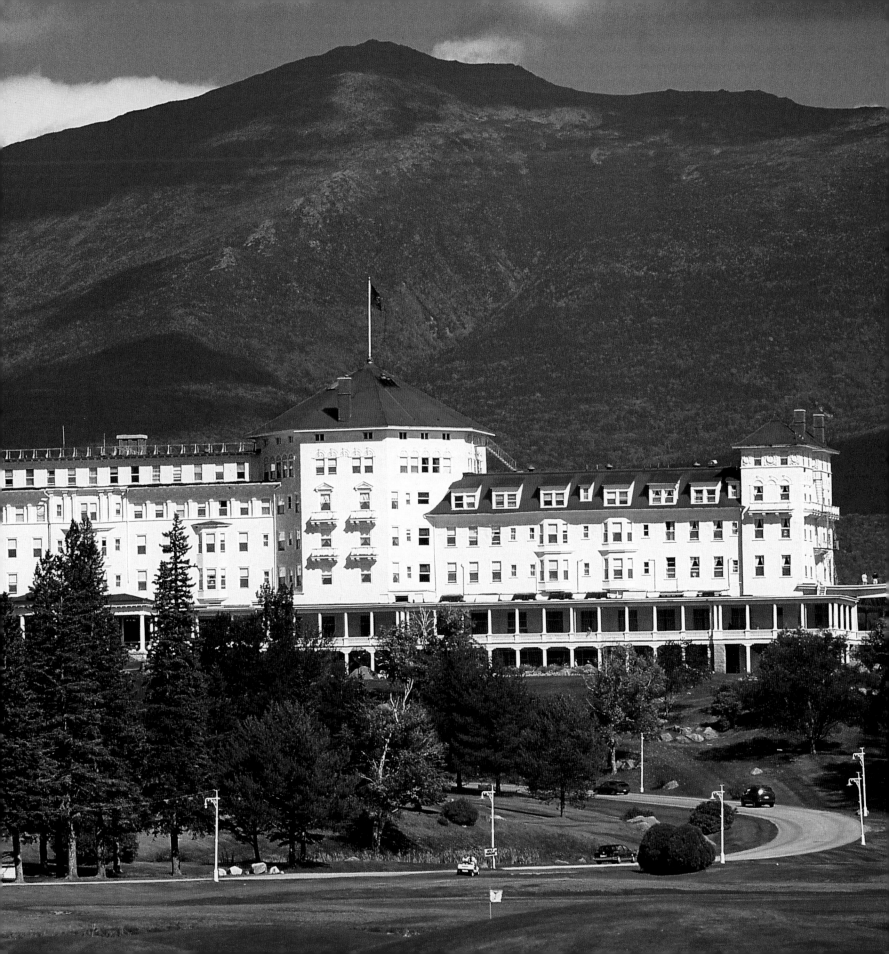

As well as serene land-
scapes such as this,
Franconia Notch State
Park has amazing for-
mations such as the
Flume, an 800-foot-
high gorge, and Old
Man of the Mountain,
a granite cliff that
resembles a man's
profile.

OPPOSITE—
A covered bridge
and the United
Methodist Church
paint a tranquil fall
scene in Stark, home
to just 500 people.

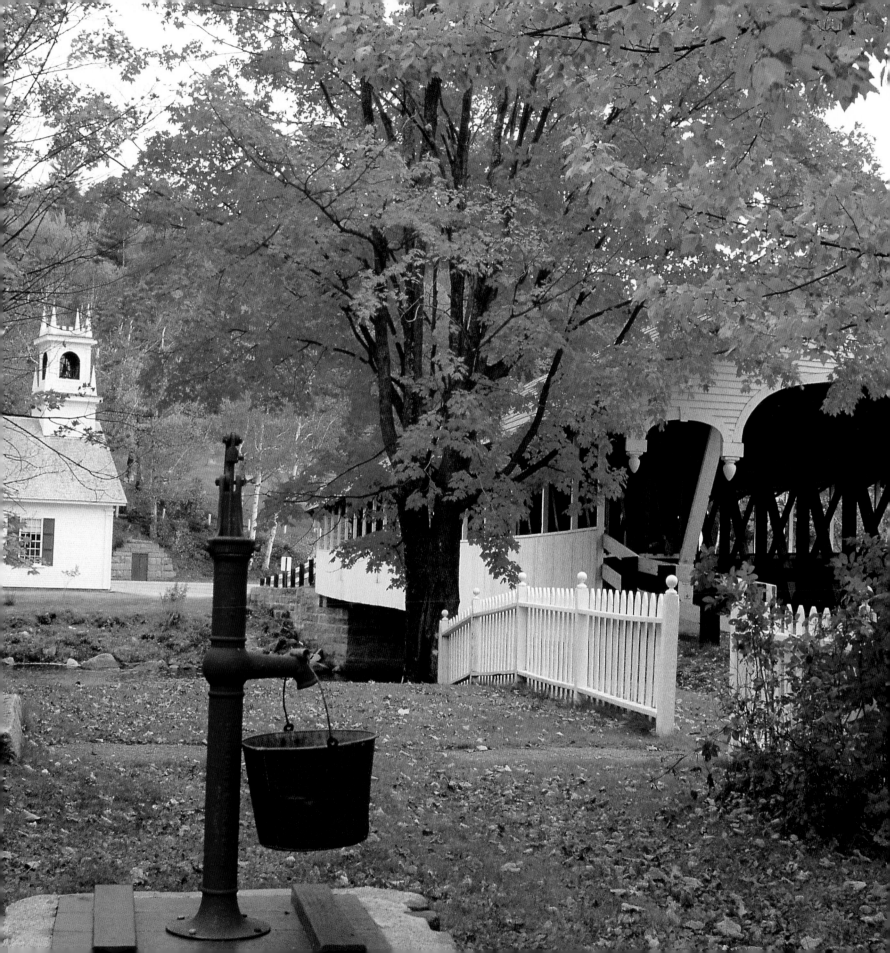

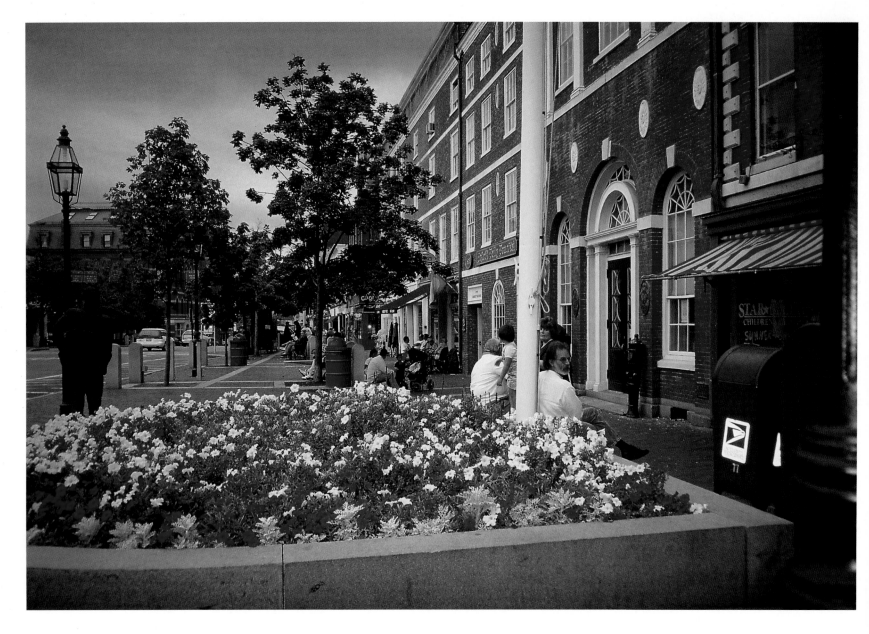

Shipbuilding has been an integral part of Portsmouth's history since the settlement's founding in 1623. The city retains the picturesque streets and brick buildings built centuries ago.

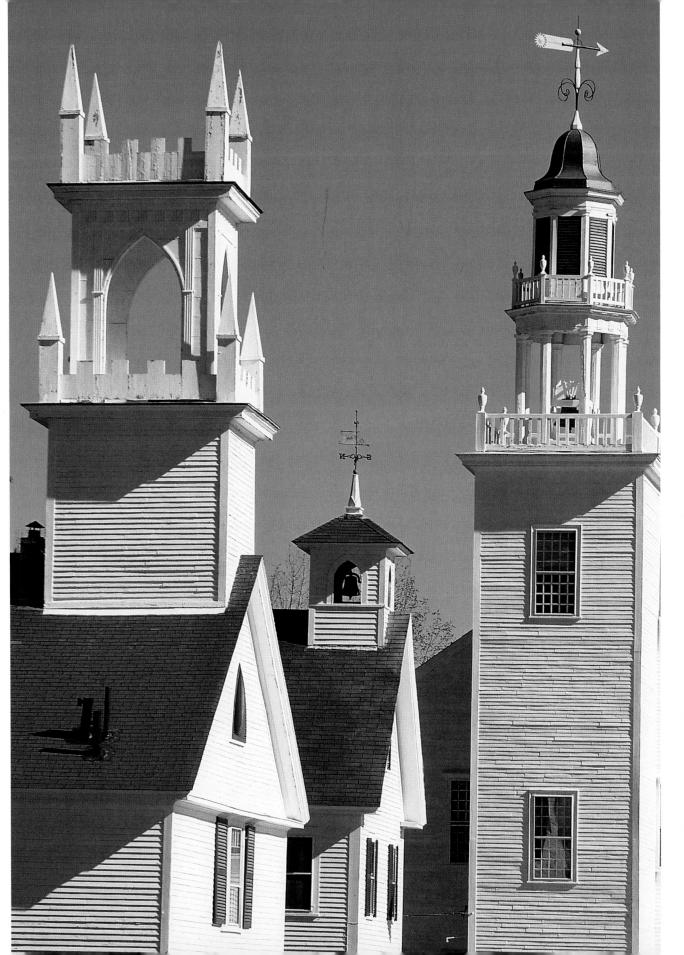

New Hampshire is
only 90 miles across
at its widest point.
The forests that cover
80 percent of the state
are interspersed with
numerous small towns
and coastal villages.

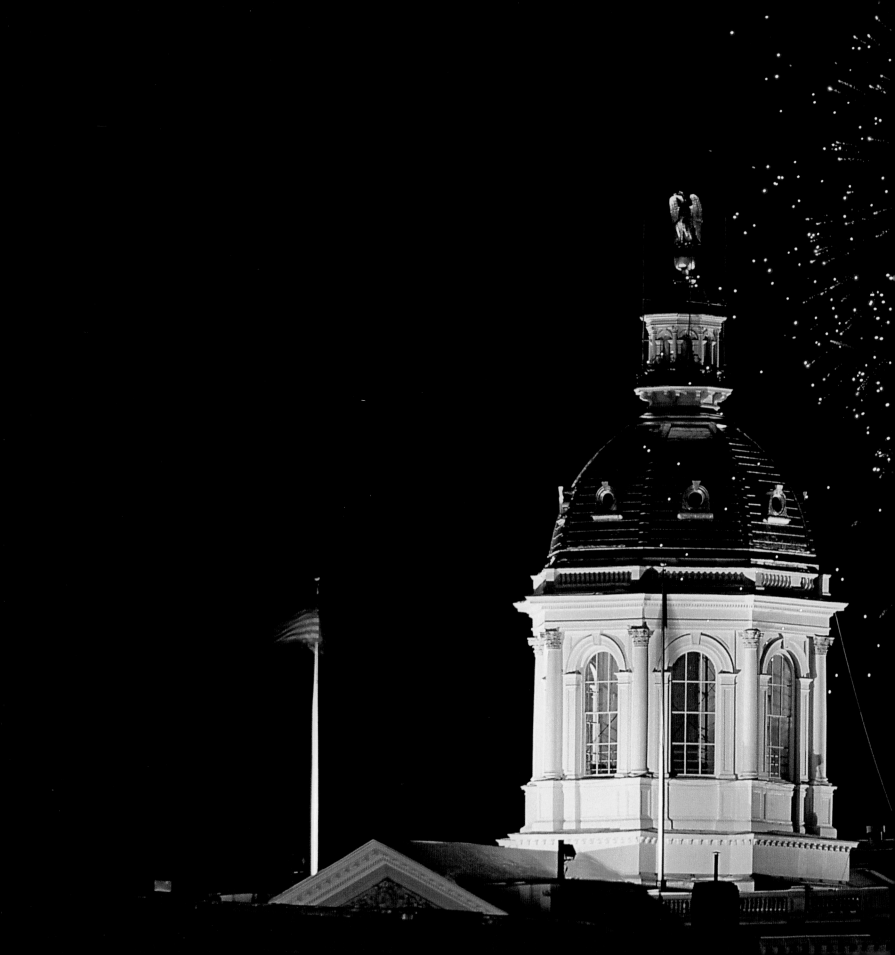

The State Capitol in Concord was completed in 1819, built of granite quarried by prisoners of the New Hampshire State Prison. The State House still sits in the building's original chambers.

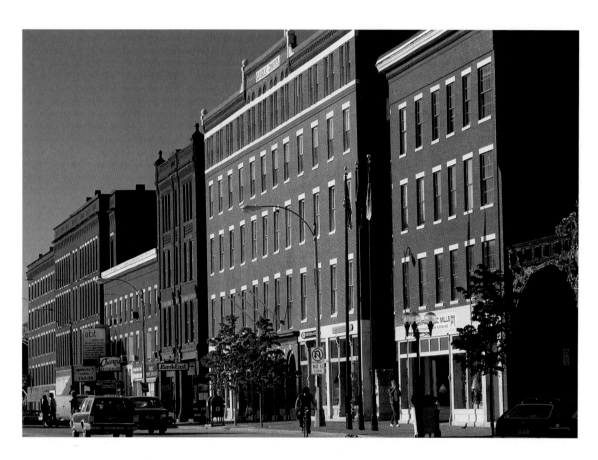

In 1808, Concord was named New Hampshire's state capital, partly because of its central location. The arrival of the railway in 1842 assured the city's continued prosperity.

From Native artifacts to a vintage Concord Coach—a famous and apparently technologically perfect coach invented here in the 19th century— Concord's Museum of New Hampshire History commemorates all ages of the state's past.

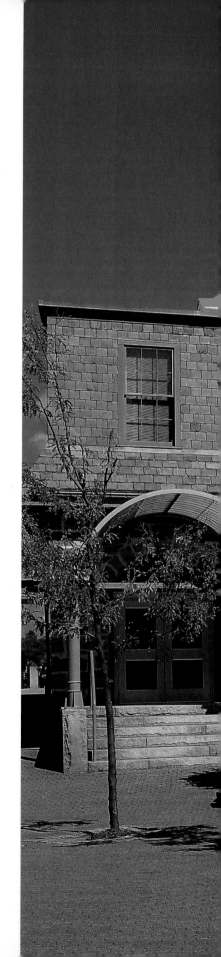

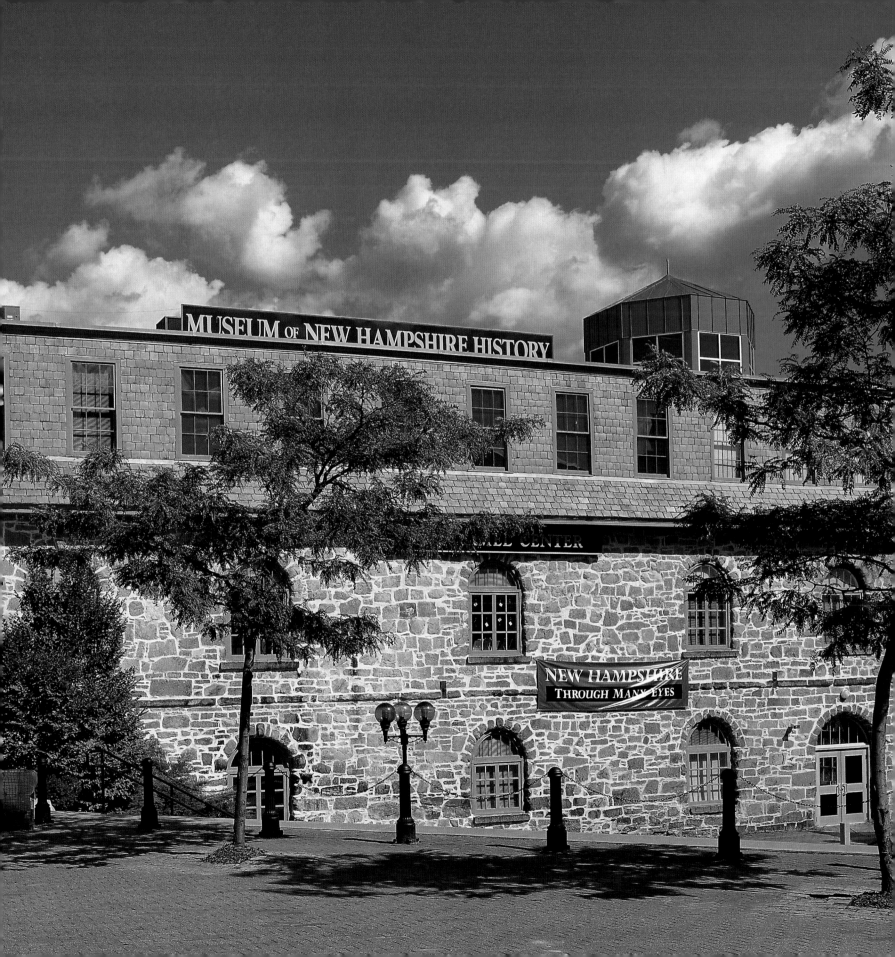

Founded in the late 18th century, the small town of Harrisville grew around the local woolen mill and is the only surviving industry town from that time still in its original form. Harrisville was declared a National Historic Landmark in 1977.

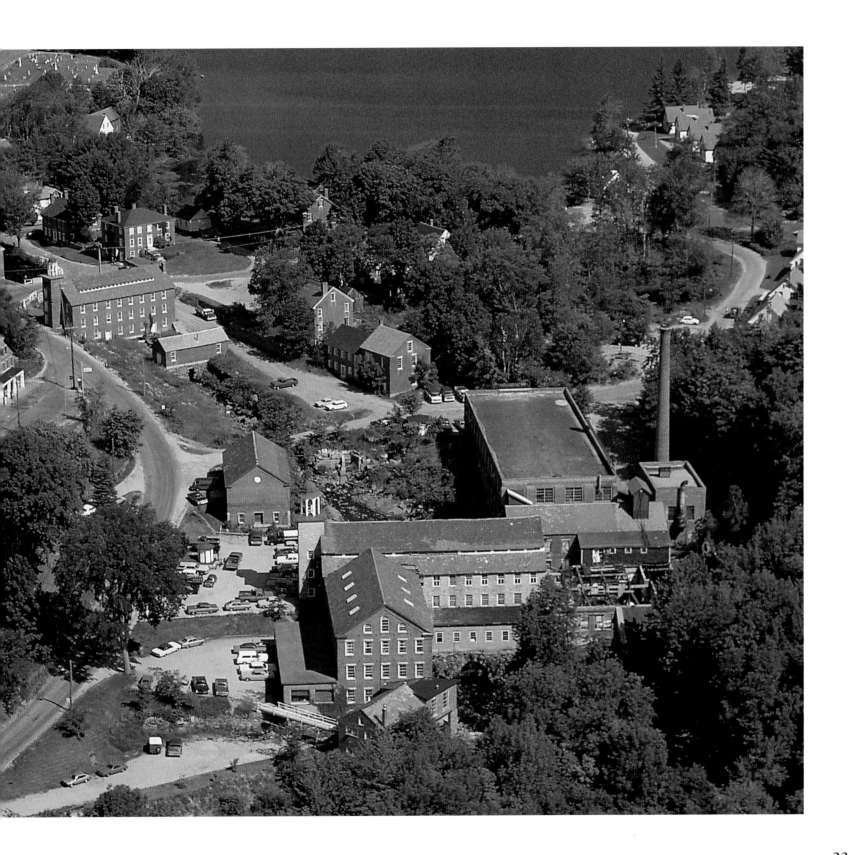

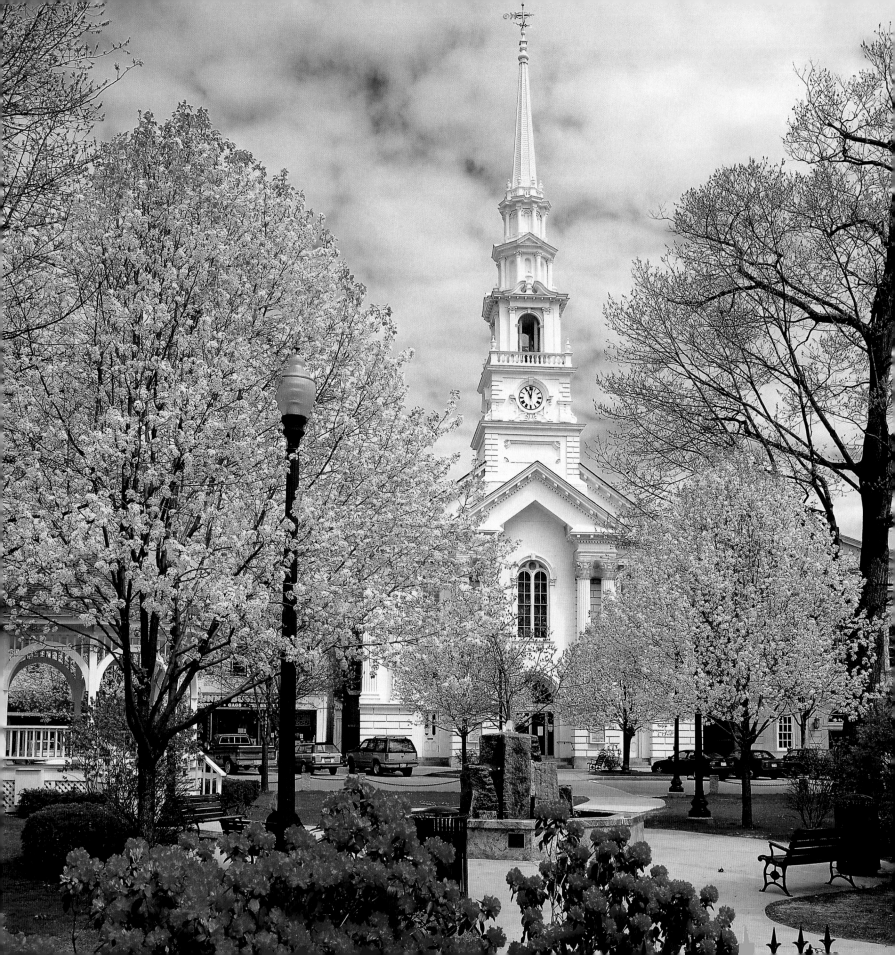

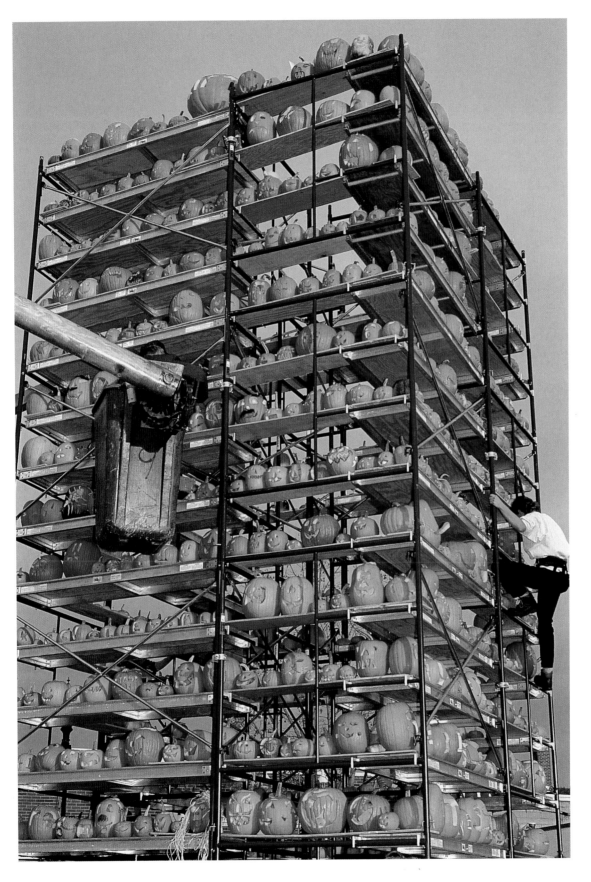

Keene holds the world record for jack-o'-lanterns—the organizers of the annual Pumpkin Festival light more than 17,000. The pumpkins are carefully counted each year by the city's mayor.

OPPOSITE—
Azaleas adorn the village green in Keene. Among the city's other attractions are the widest main street in the nation and the lively surroundings of Keene State College.

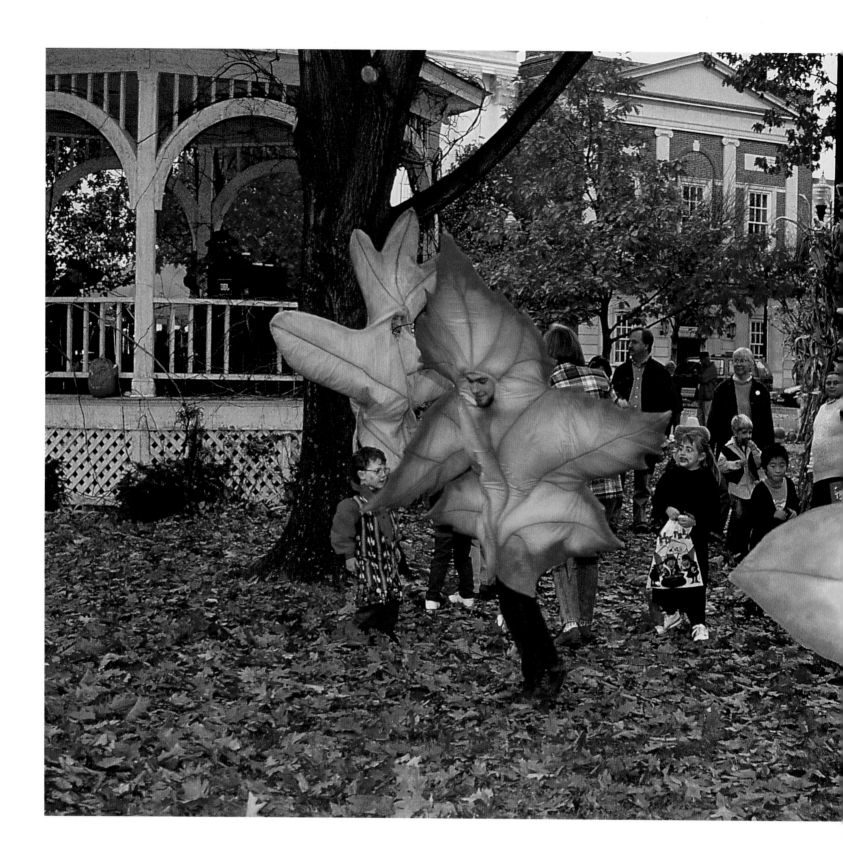

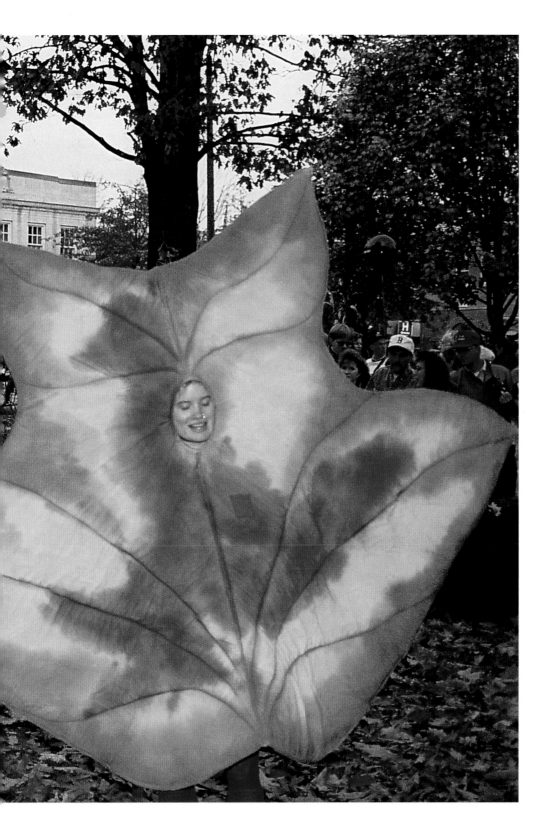

Along with the tower of pumpkins, Halloween events in Keene include hay rides, fire engine rides, and trick-or-treating. One year, a beau in the holiday spirit carved his proposal into pumpkins during the festival.

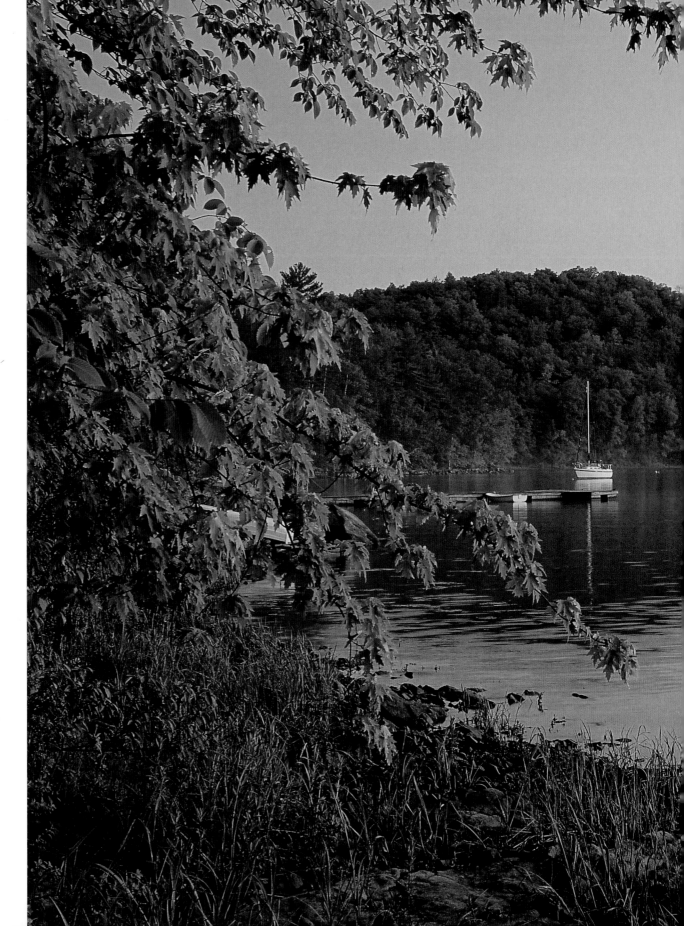

Stretching across the Canadian border into Quebec, Lake Champlain is the sixth largest lake in the U.S. The area is one of Vermont's most popular boating and fishing destinations.

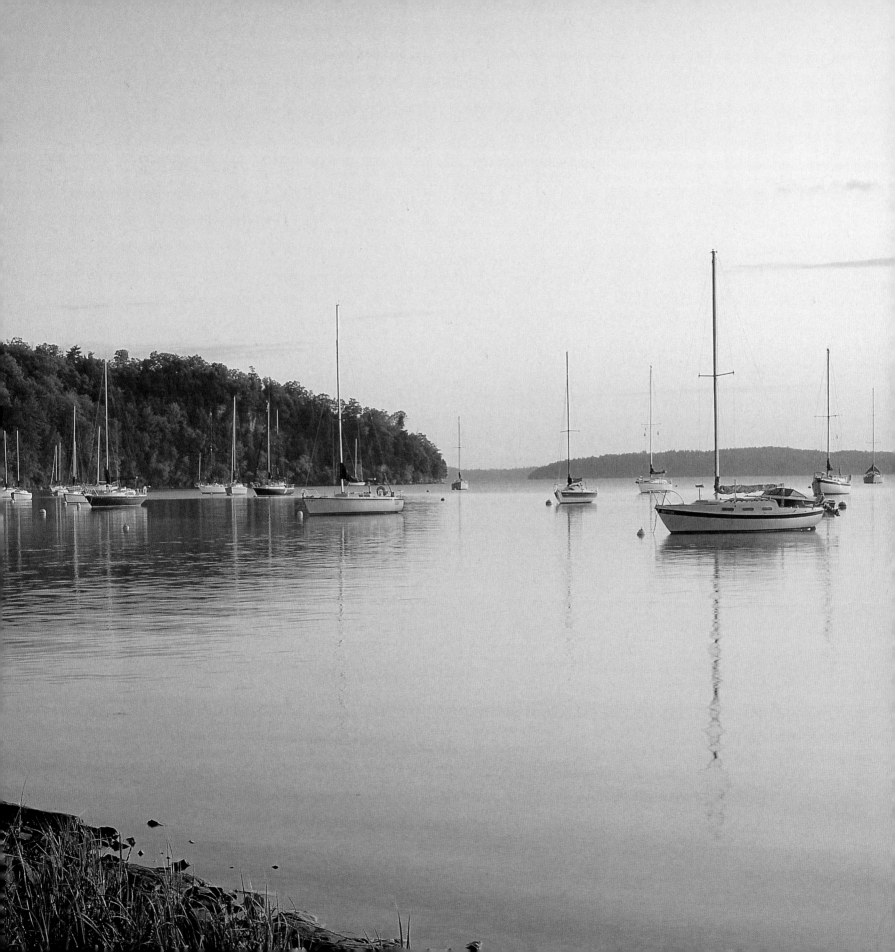

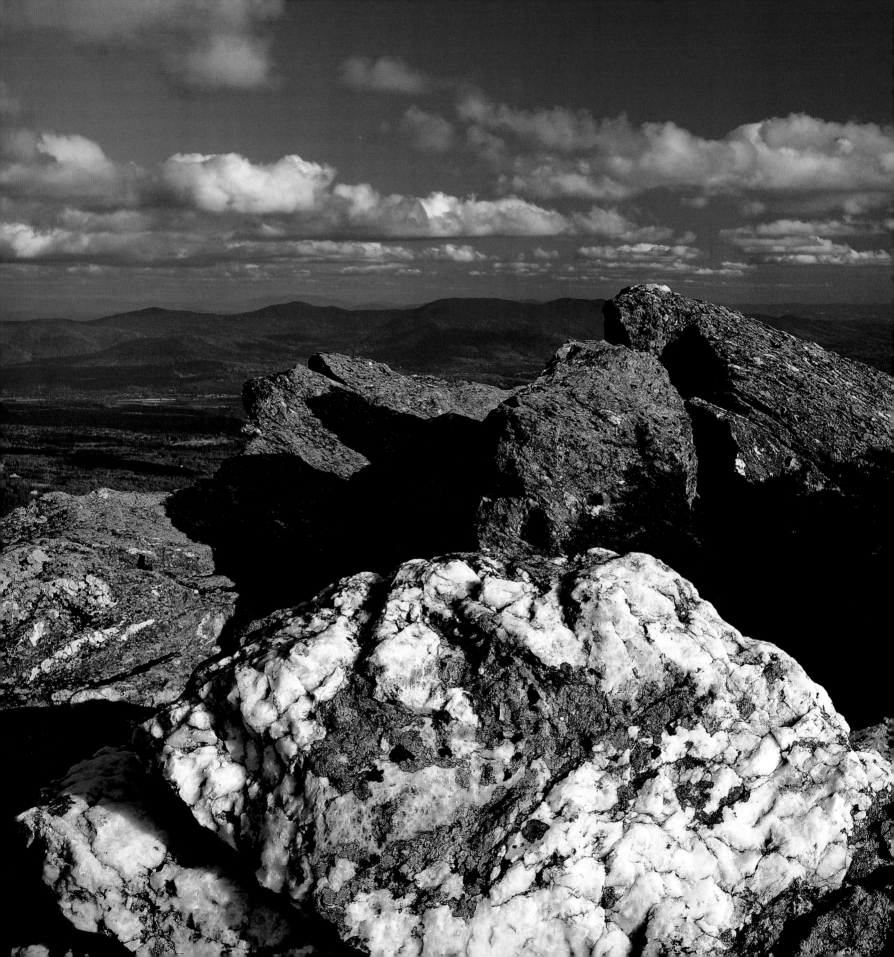

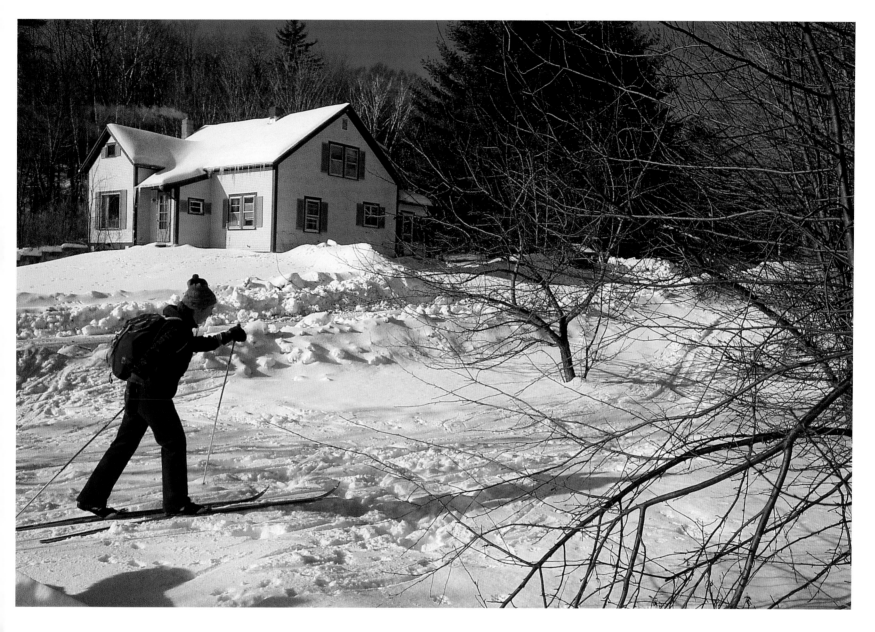

From cross-country skiing in the surrounding hills and downhill skiing on Mount Mansfield to summer cycling and hiking, the town of Stowe is a mecca for outdoor enthusiasts.

At 4,383 feet high, Mount Mansfield soars above Vermont. A gondola whisks visitors to the summit, where they can take in a panoramic view of the region.

When the von Trapp family of *The Sound of Music* fame escaped Austria, they settled in Stowe, choosing the area partly because the local mountains reminded them of the Alps. The family established a lodge and singing camp nearby.

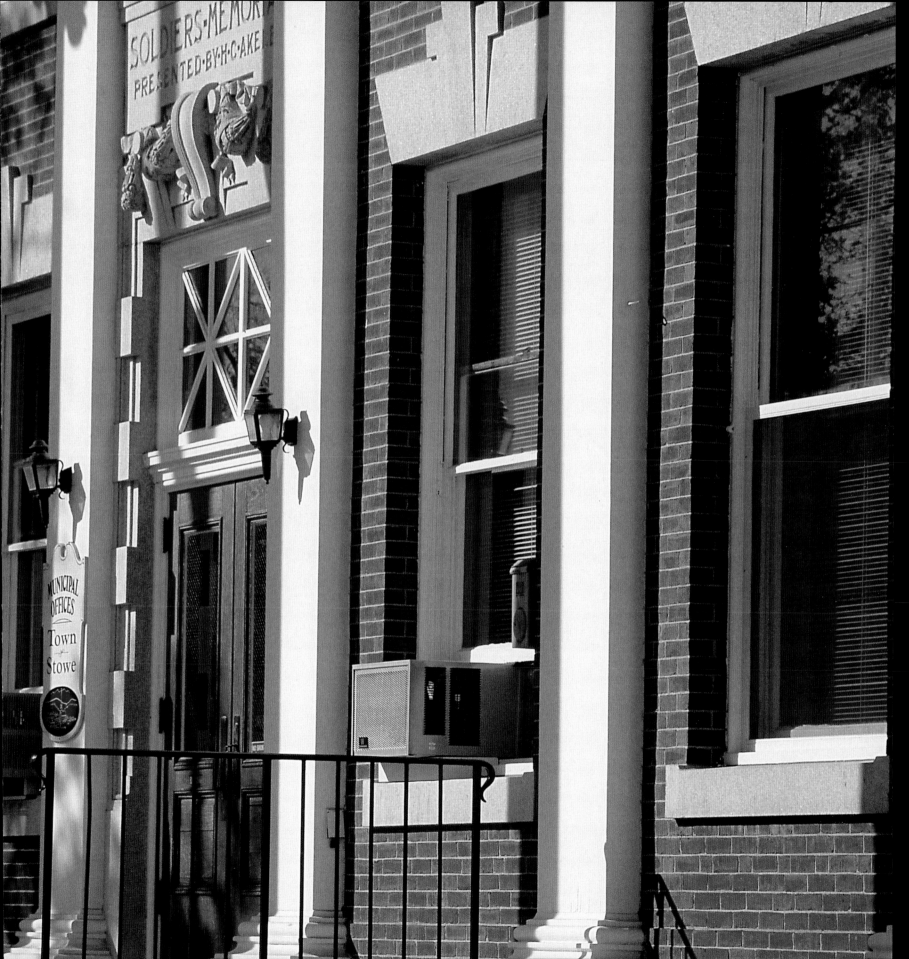

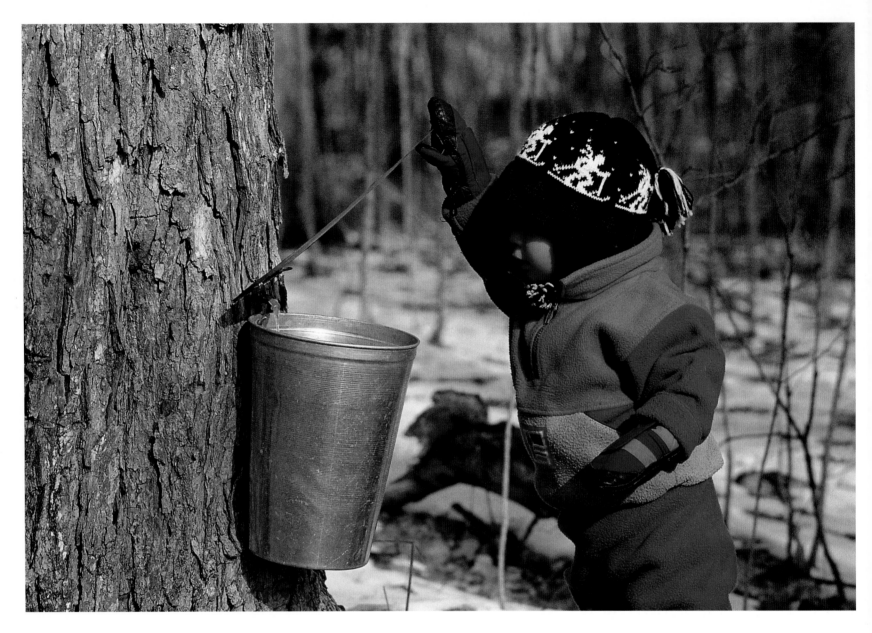

Traditionally, when making maple syrup, trees are tapped
to allow sap to run into metal buckets. The buckets are then
carried to the sugarhouse where the sap is boiled. Vermont
produces half a million gallons of maple syrup each spring.

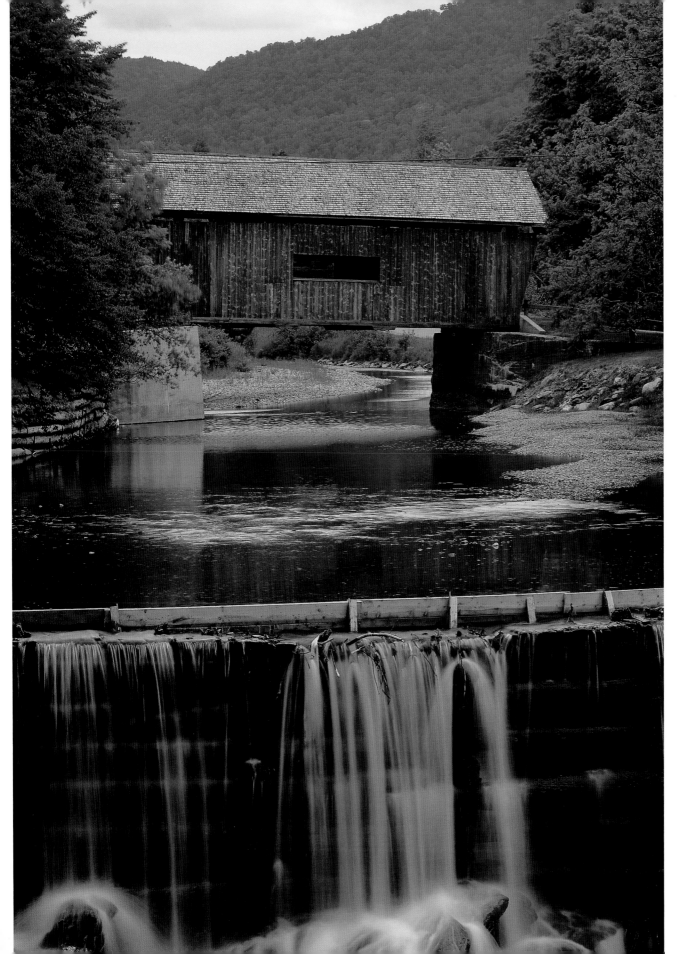

Set in the midst of Vermont's ski region, the rural beauty of Warren, complete with a covered bridge across the rushing Mad River, offers a quiet retreat to both visitors and residents.

45

The sparkling dome
of Vermont's State
Capitol dominates
Montpelier, a town
of fewer than 10,000
people. Built of local
granite, the capitol
was completed
in 1859.

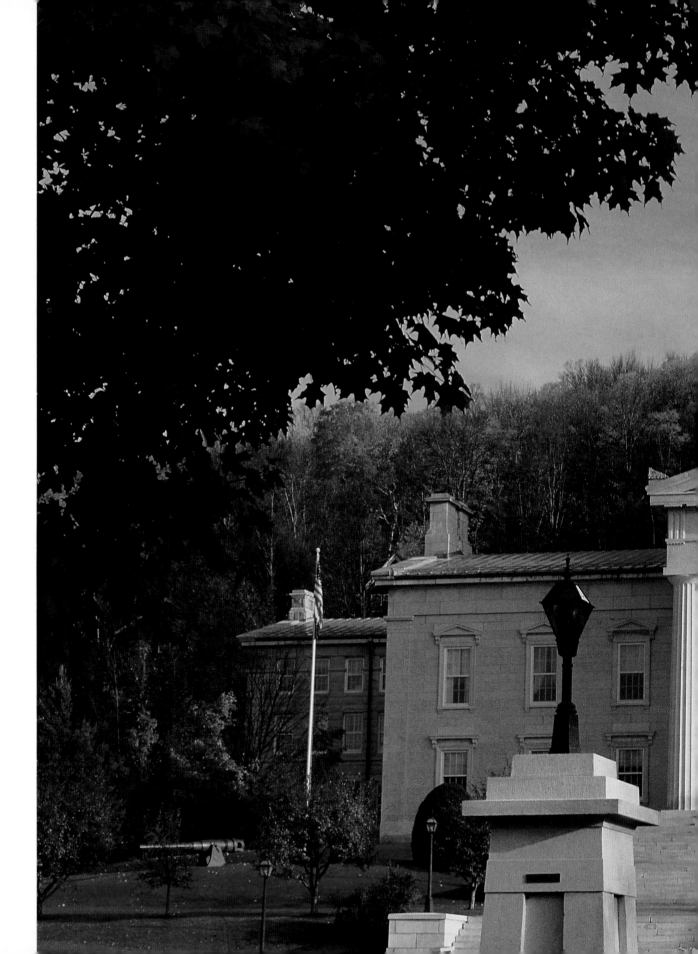

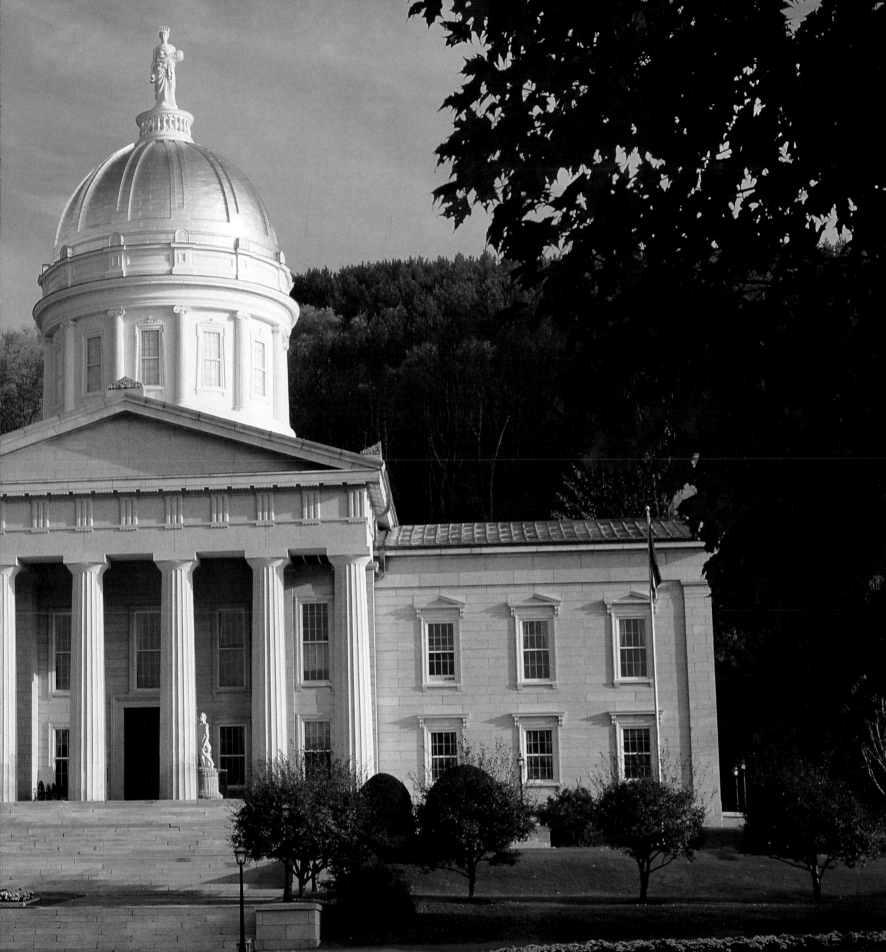

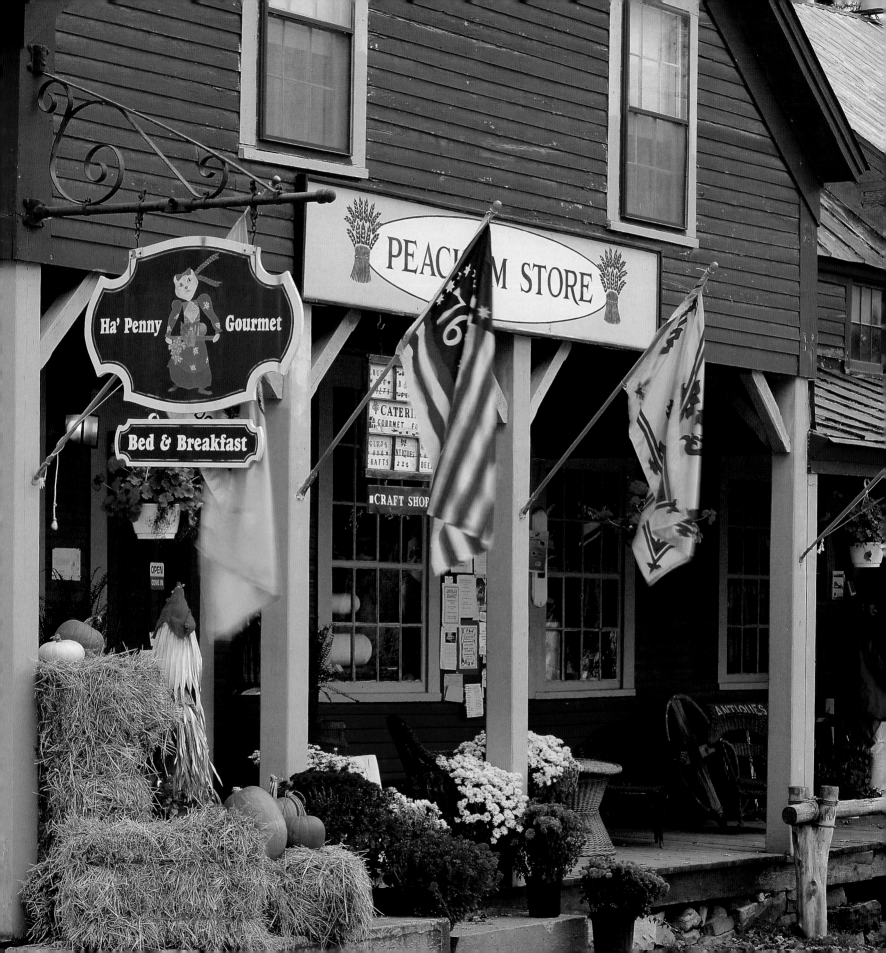

The church bells in Woodstock have a rare claim to fame—they were cast by New England legend Paul Revere. The Rockefellers have been residents of this region for more than a century.

OPPOSITE—
The tiny village of Peacham is believed to have been named after character Polly Peacham in John Gay's *The Beggar's Opera*. The actress who played the role in 18th-century Britain, Lavinia Fenton, married a duke and her real-life romance story was followed devotedly in Britain and America.

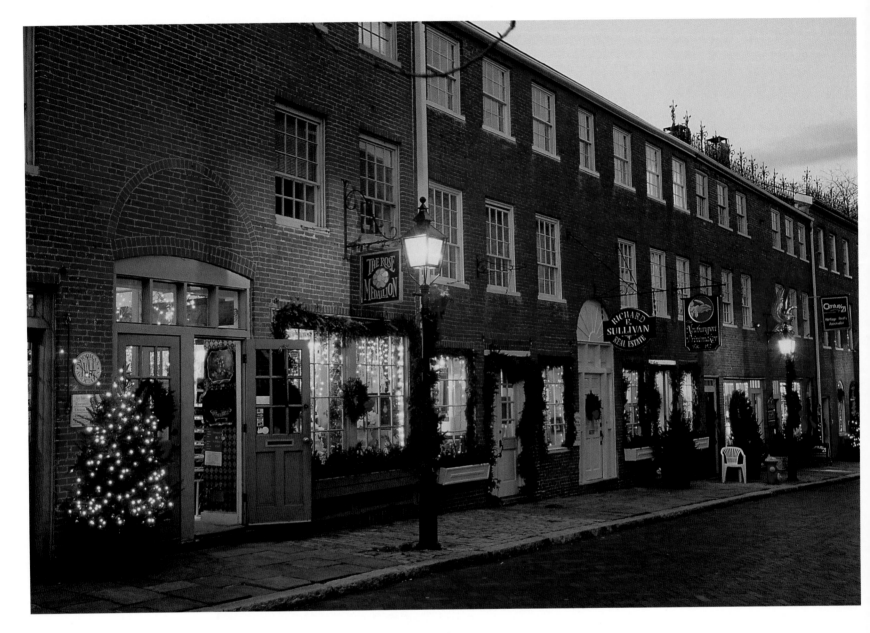

Christmas gifts and decorations adorn the shop windows of
Newburyport. Once a prosperous port, this charming town is
known for the heritage mansions of Victorian sea captains.
Many homes are complete with widow's walks, where sailors'
wives could watch for the return of their husbands' ships.

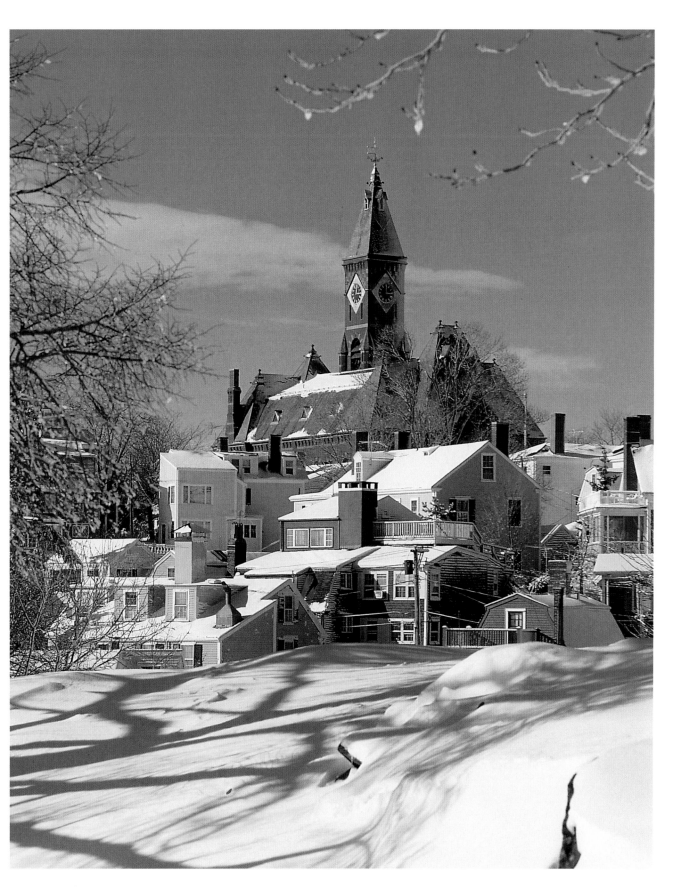

In 1760, Marblehead was the sixth largest city in the American colonies. Abbot Hall, visible here amidst the town's historic district, houses Archibald M. Willard's famous painting *The Spirit of '76*.

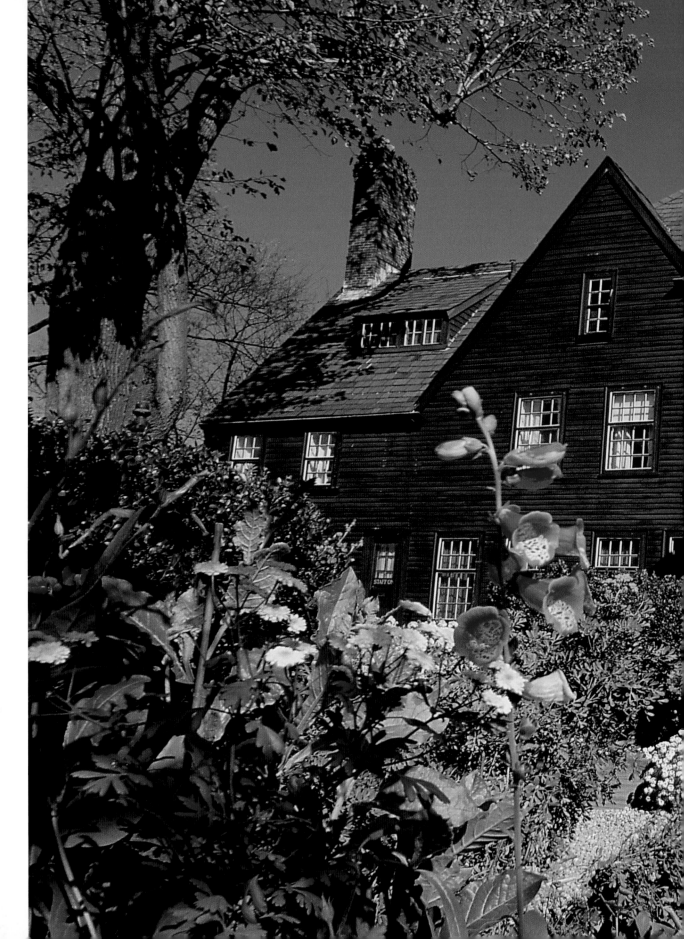

Salem—best known as "Witch City"—has more to its history than the infamous witch trials. The House of Seven Gables, pictured here, was the inspiration for 19th-century resident Nathaniel Hawthorne's book of the same name.

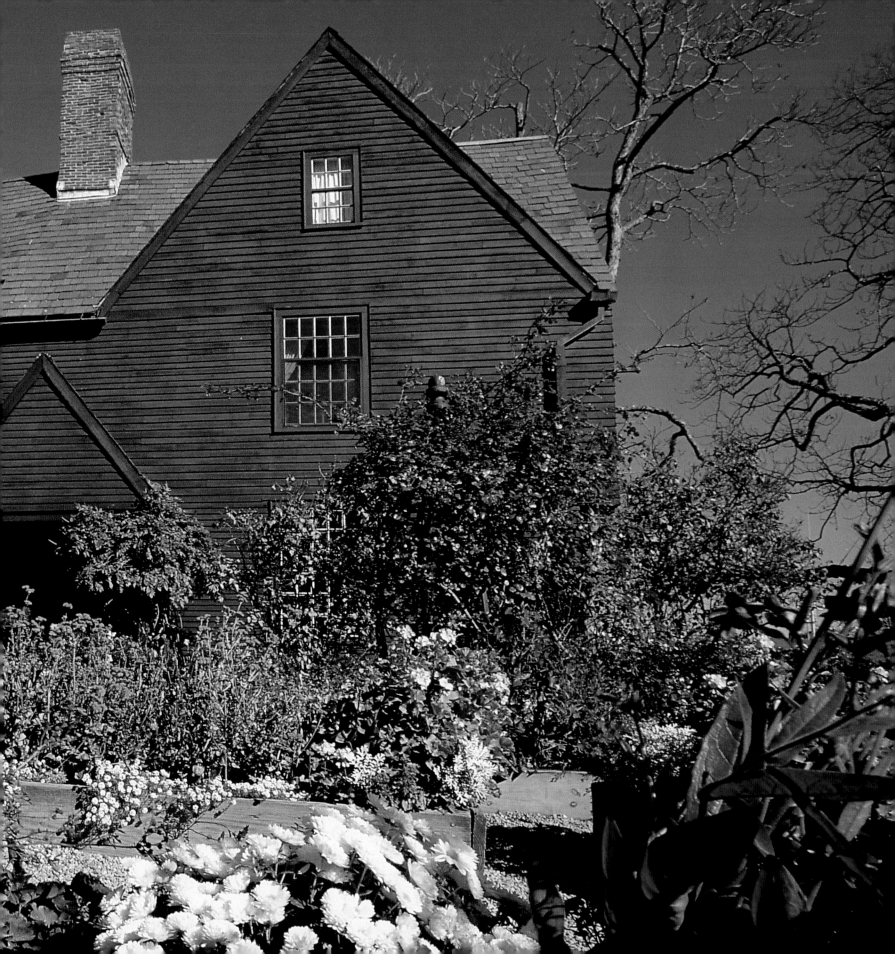

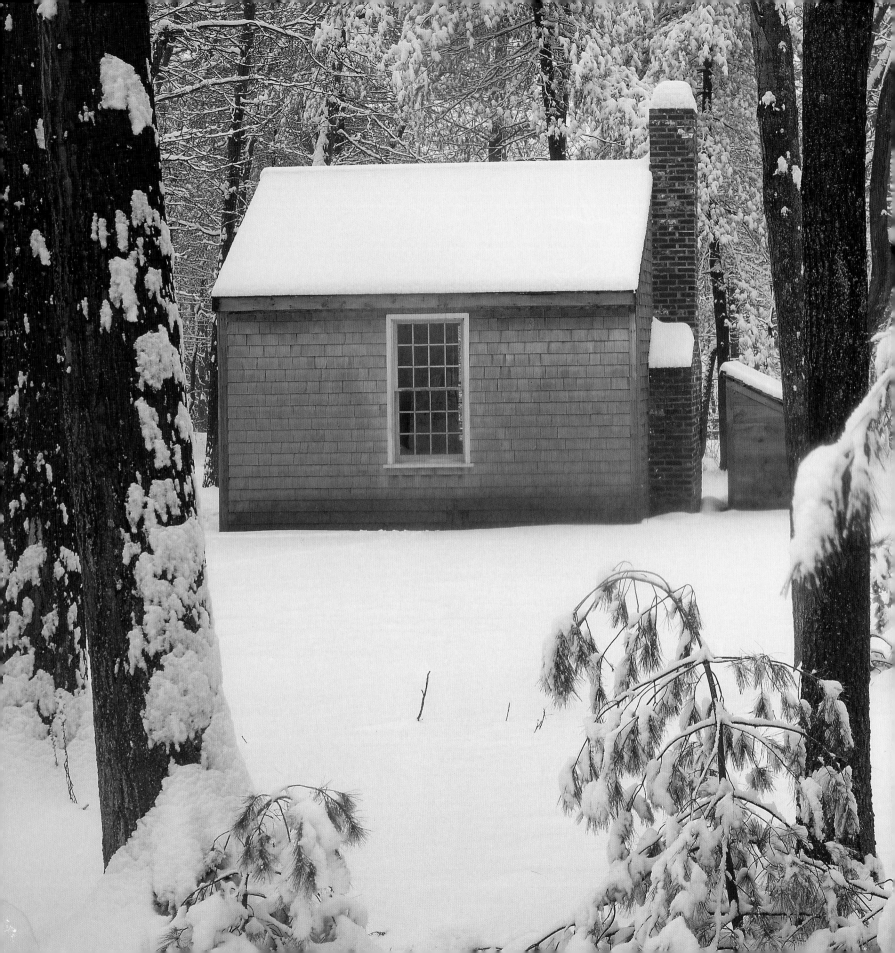

Now a national historic landmark, Walden Pond was the home of Henry David Thoreau from 1845 to 1847. The area inspired his book *Walden*, which helped spark the environmental conservation movement.

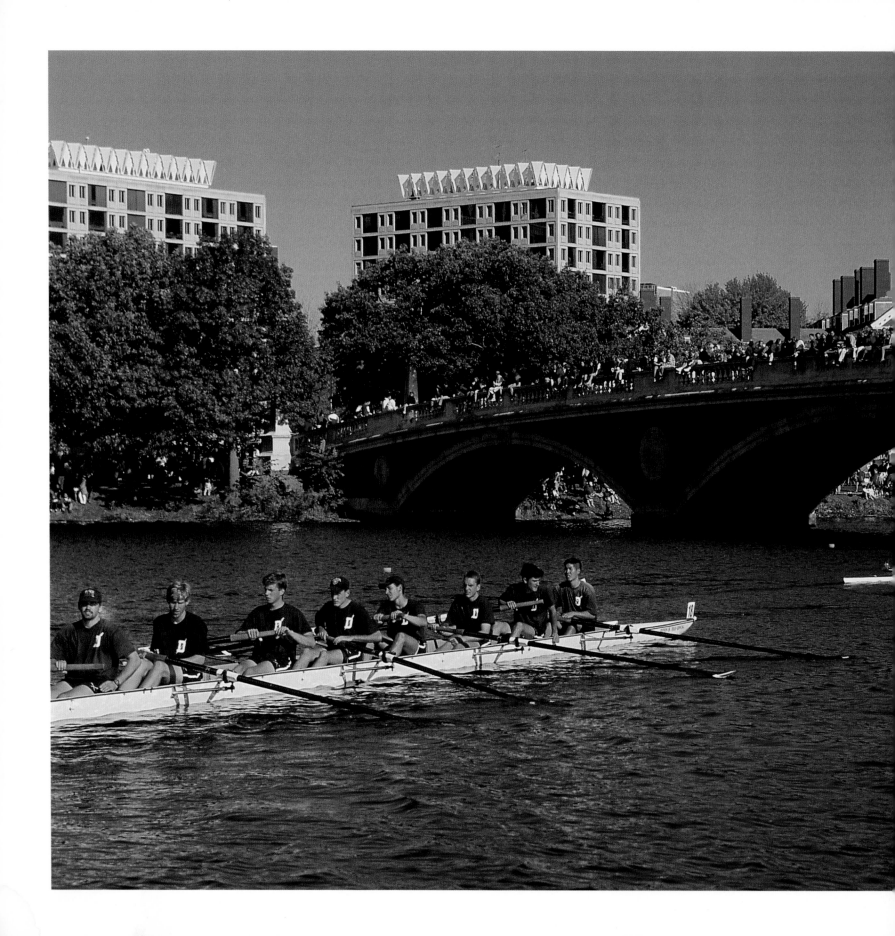

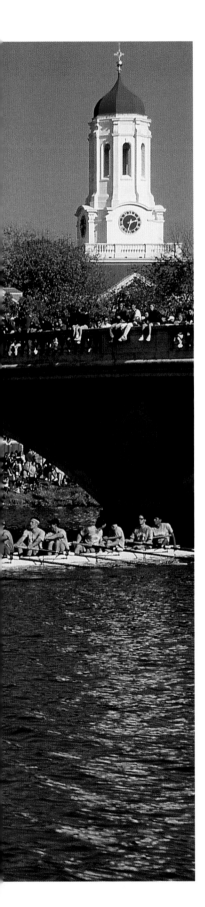

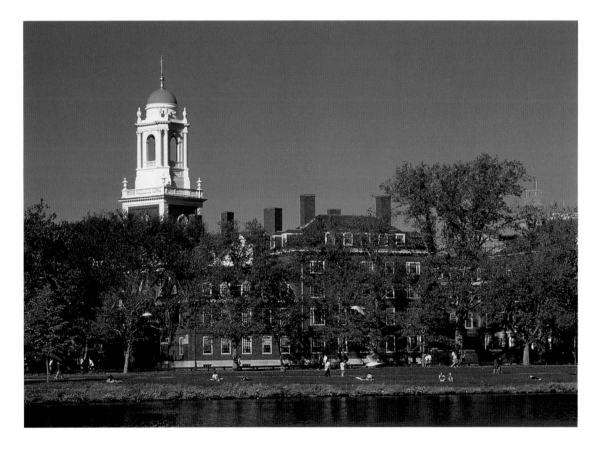

More than 350 years old, Harvard University in Cambridge was founded only 16 years after the pilgrims arrived at Plymouth. More than 18,000 students study here under 2,000 faculty members.

The Head of the Charles Regatta is held each October in Cambridge on the Charles River. The largest two-day rowing event in the world, it draws 5,500 participants. Winners claim the title "Head of the Charles."

The State House in Boston soars over centuries of history. Among other major events, this city was the site of the 1773 Boston Tea Party, when American colonists boarded British ships and dumped more than 300 chests of tea overboard to protest high taxes on the beverage.

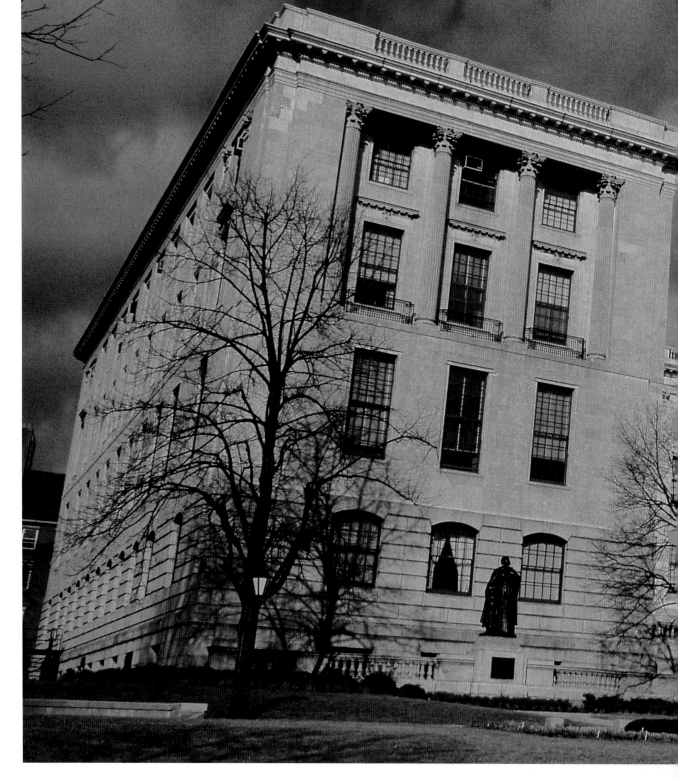

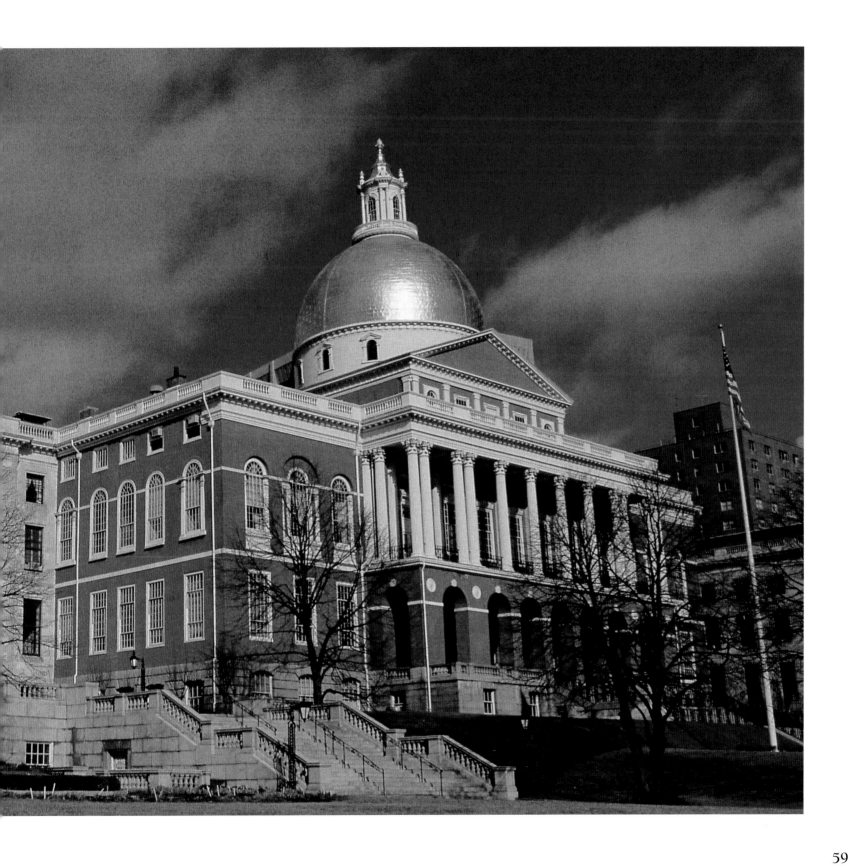

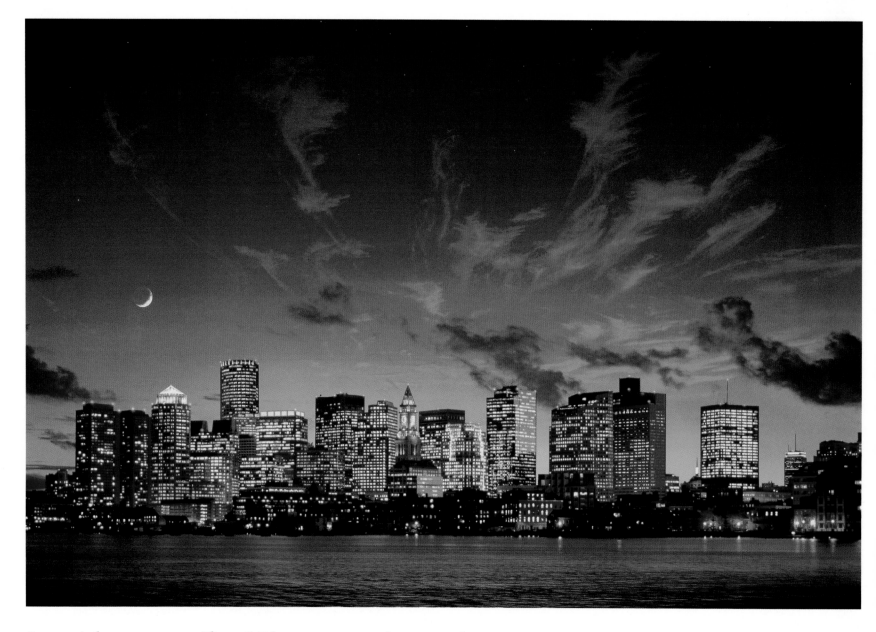

Boston is home to many "firsts." Ether was invented at Massachusetts General Hospital in 1846. Alexander Graham Bell invented the telephone here in 1876, and the world's first fire alarm was installed in Boston.

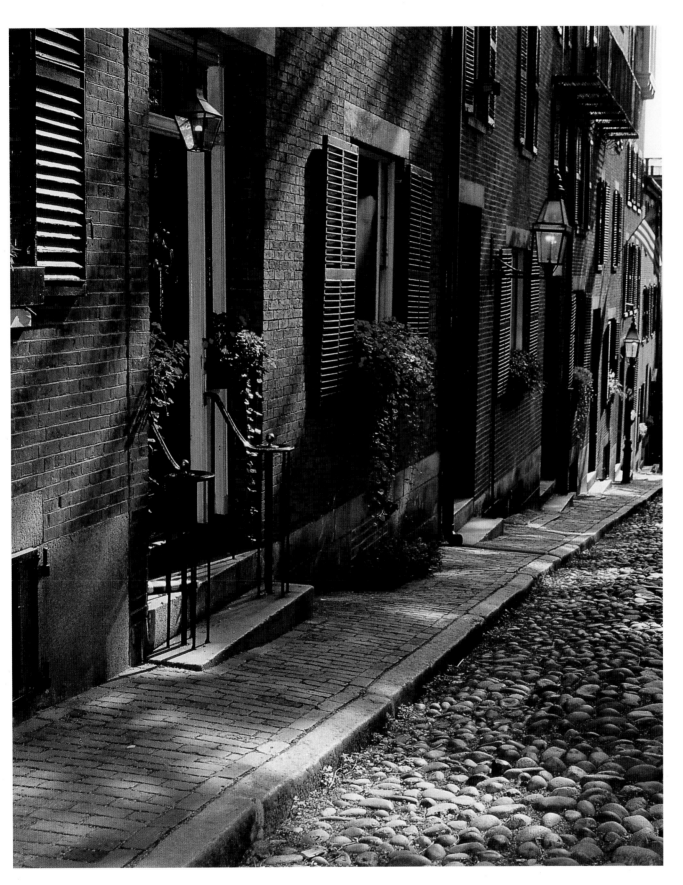

When the city of Boston planned to revamp the streets of Beacon Hill in the 1940s, local women staged a sit-in so that the characteristic brick sidewalks would be preserved.

61

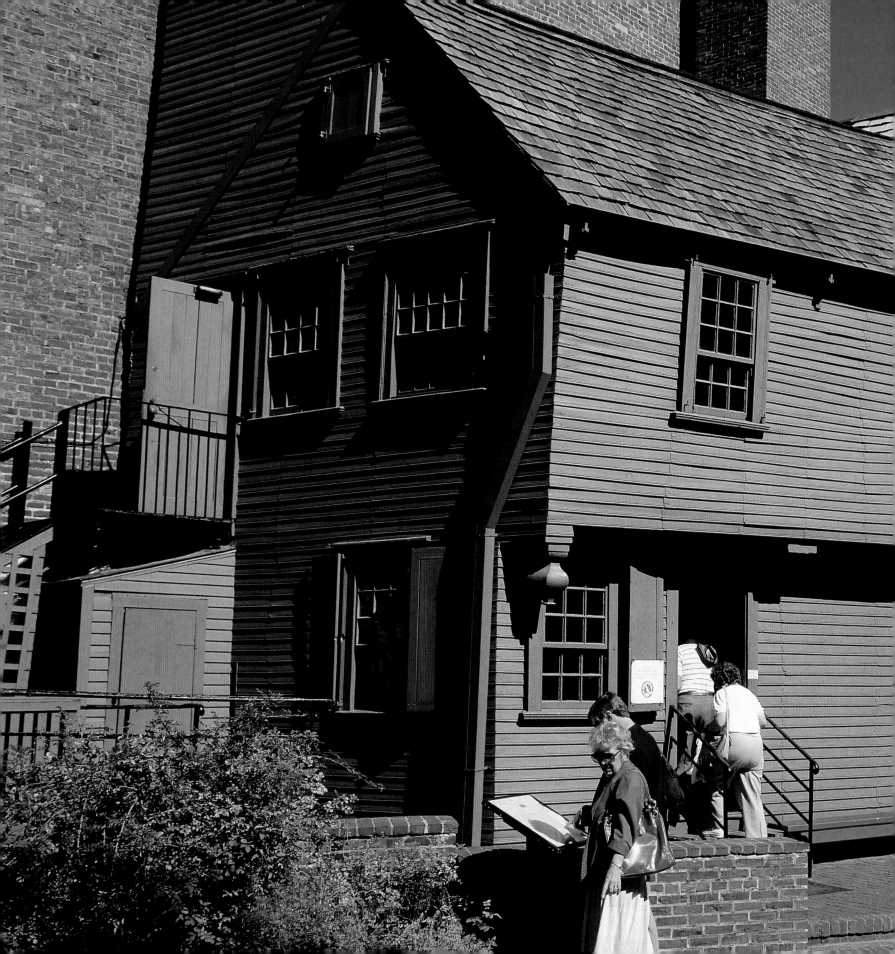

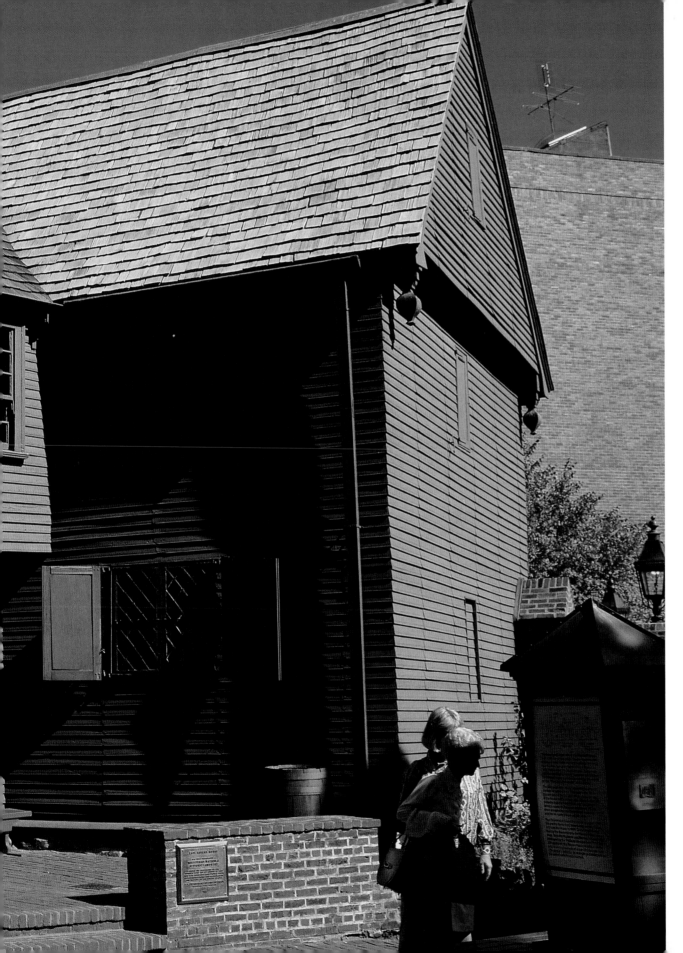

In 1775, Paul Revere rode from Boston to Lexington, warning of an impending British attack. His journey was immortalized in Henry Wadsworth Longfellow's poem *Paul Revere's Ride*. Today, visitors can take a self-guided tour of the silver-smith's home.

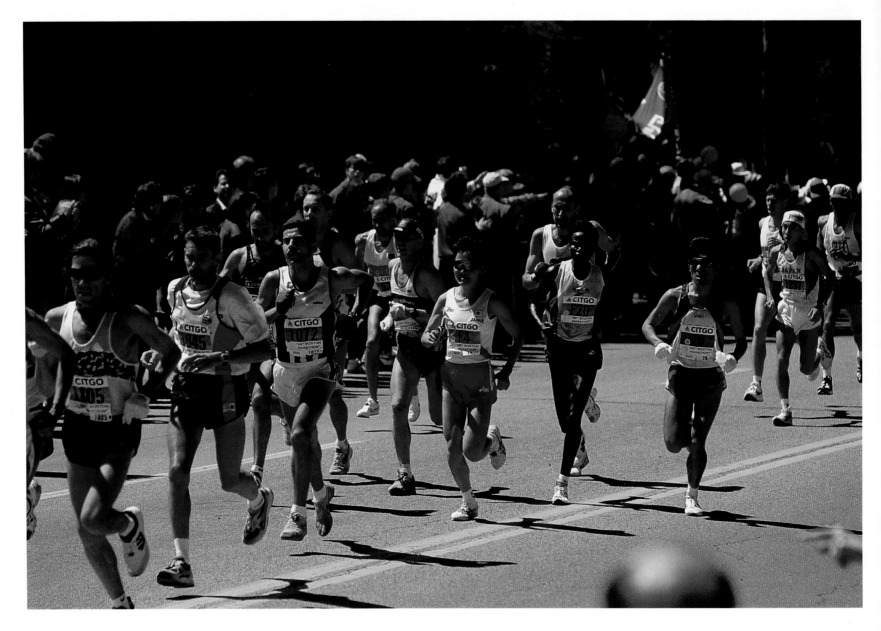

For more than 100 years, runners have converged on Boston every April for the world-renowned Boston Marathon. More than 30,000 runners participate, along with more than 2,000 medical personnel, almost 200 massage therapists, and 10,000 volunteers.

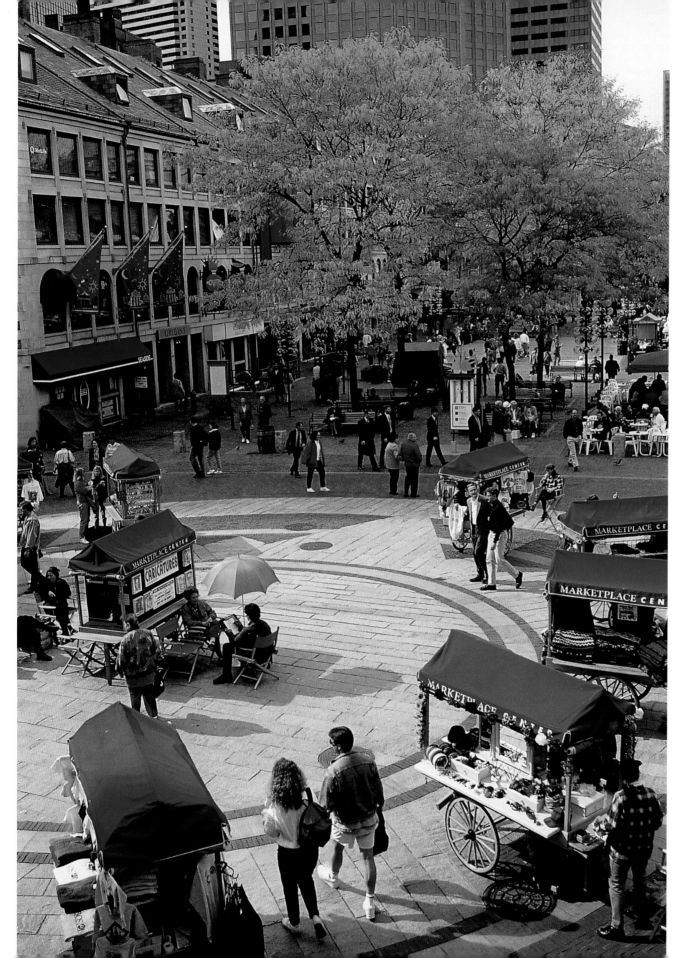

Pushcarts offer art, crafts, and giftware to passersby. The colorful vendors are part of Faneuil Hall Market-place, a complex of galleries, restaurants, and retail stores.

65

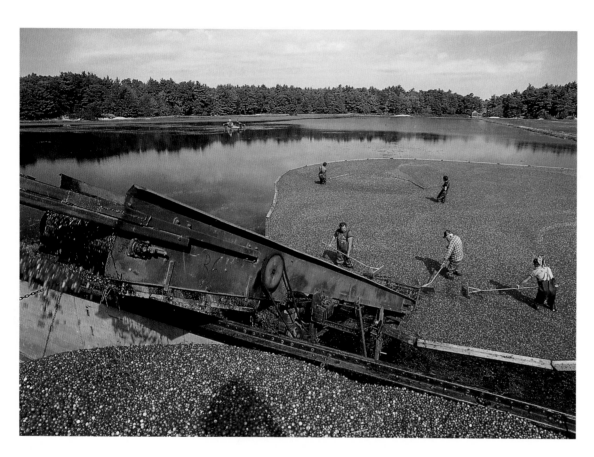

Cranberries are indigenous to New England and have been cultivated since the mid-19th century. Cranberries are Massachusetts' most important agricultural product and workers harvest more than 12,000 acres each year.

Best known for celebrating the first Thanksgiving, the pilgrims arrived in present-day Massachusetts in 1620. Just over 100 passengers made the voyage on the *Mayflower*, but only half survived the first New England winter.

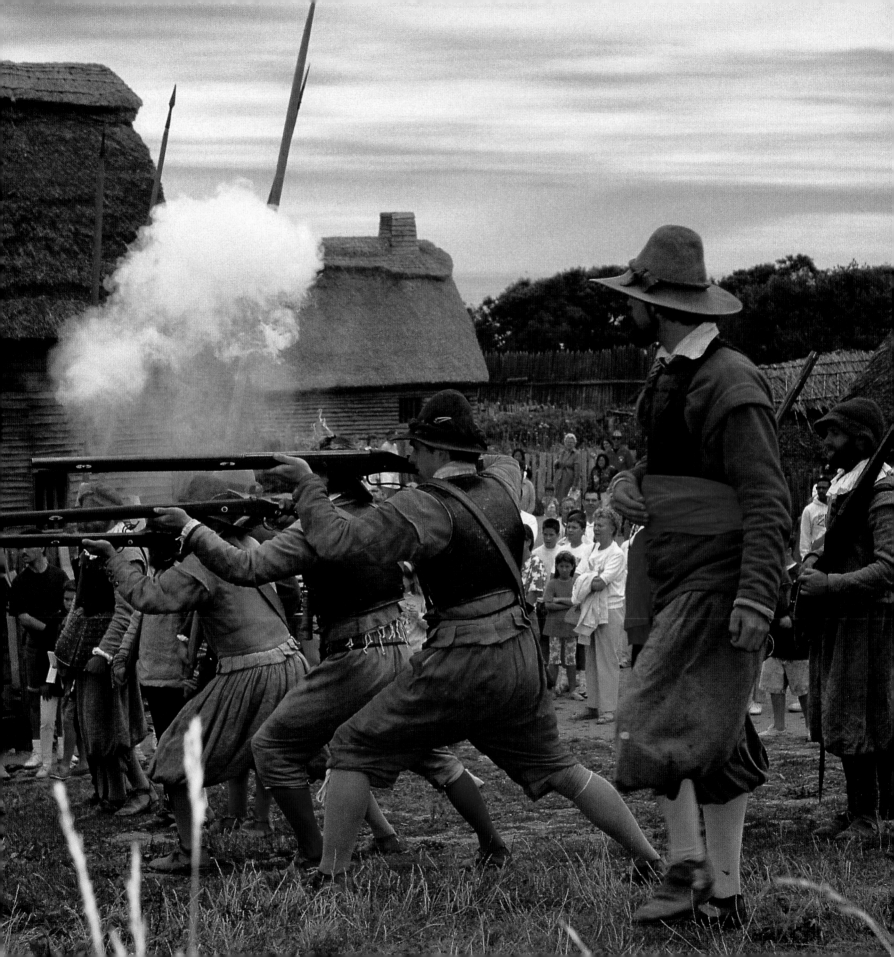

In 1620, the pilgrims anchored in Province-town's harbor, remaining for more than a month before moving on to Plymouth. Today, the city is best known for its thriving arts community and galleries line the busy streets.

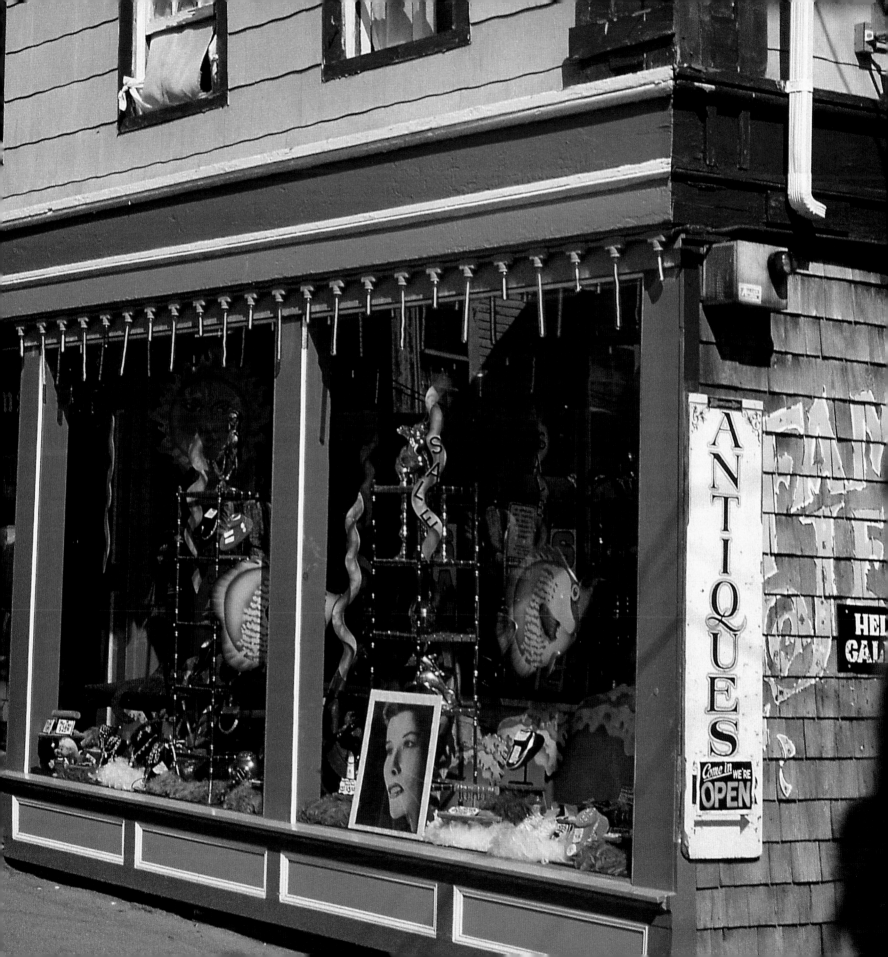

Built in 1663,
Brewster Mill is
still grinding corn,
mostly for tourists
as a souvenir of
Cape Cod.

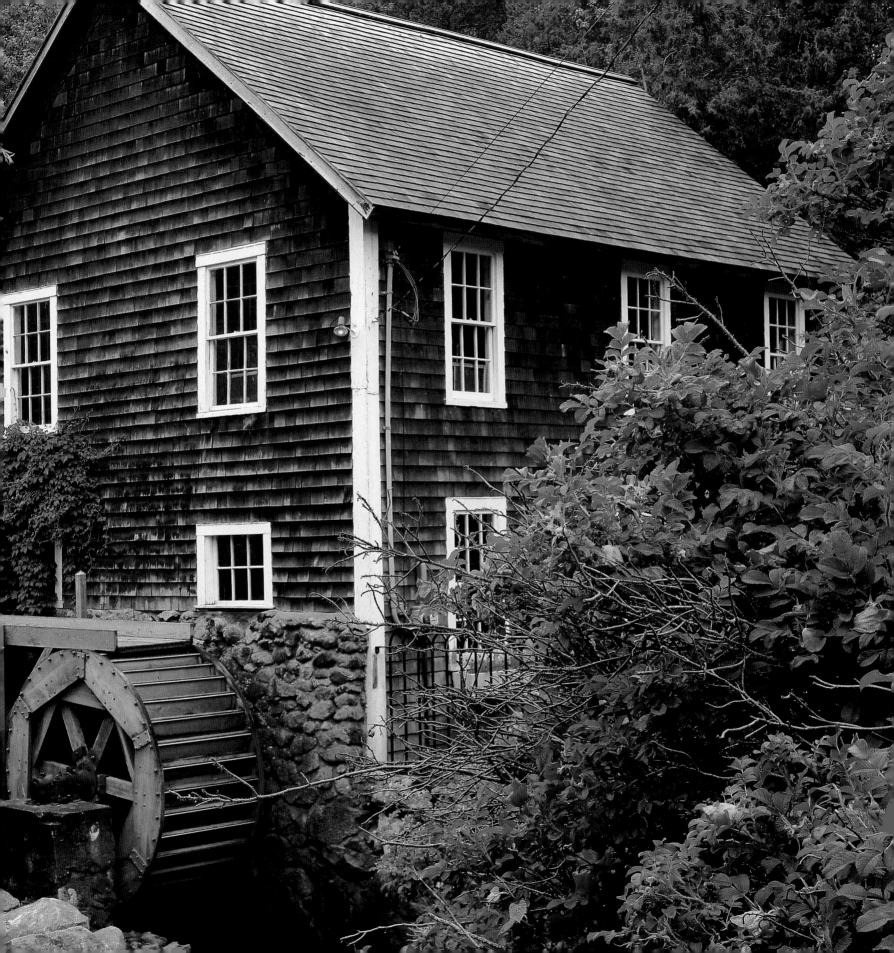

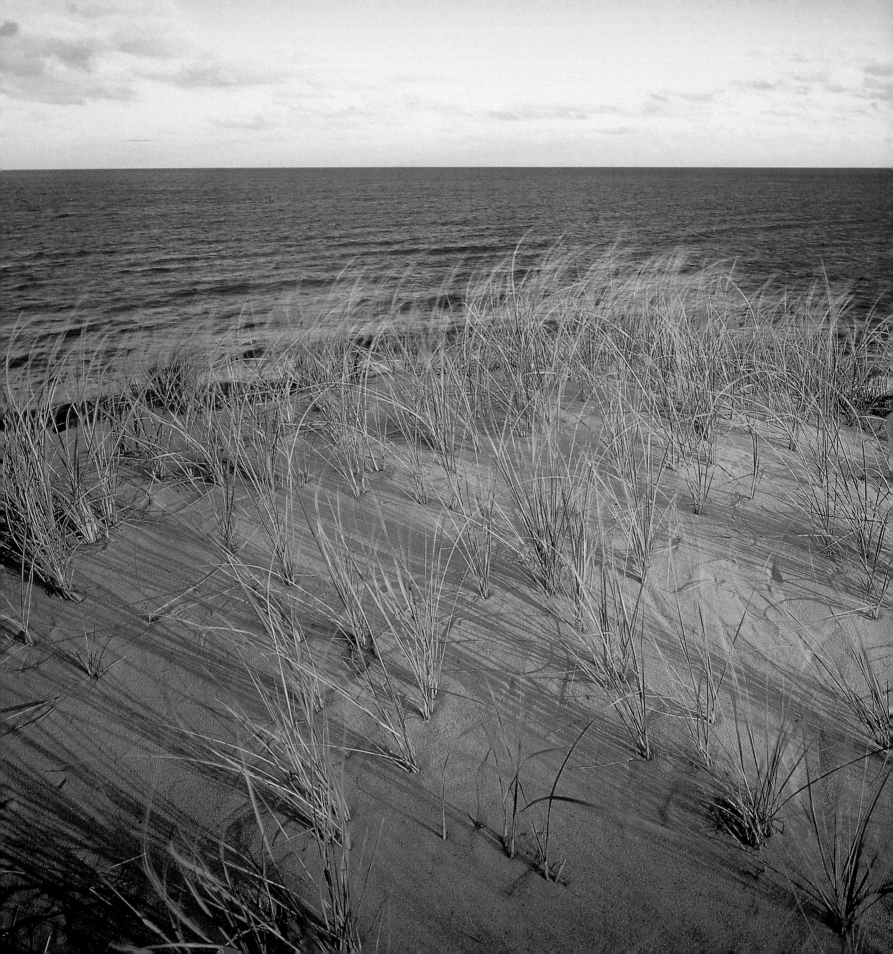

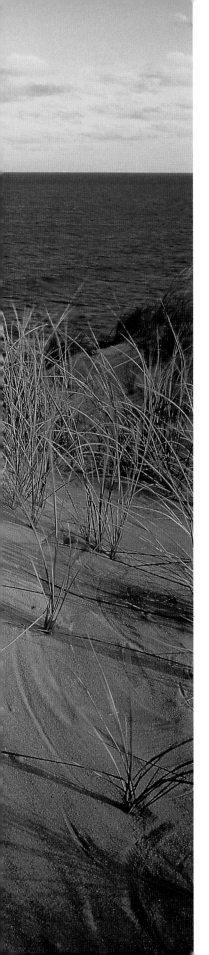

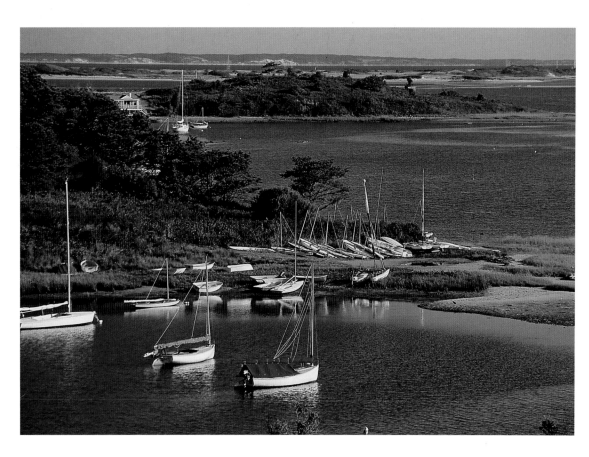

According to local legend, British explorer Bartholomew Gosnold discovered Martha's Vineyard in the 1600s. He named it for his daughter Martha and for the abundant grapes he found growing wild on the island.

Cape Cod National Seashore encompasses 43,557 acres, including a pristine 40-mile stretch of shoreline. About 5 million people visit the area each year.

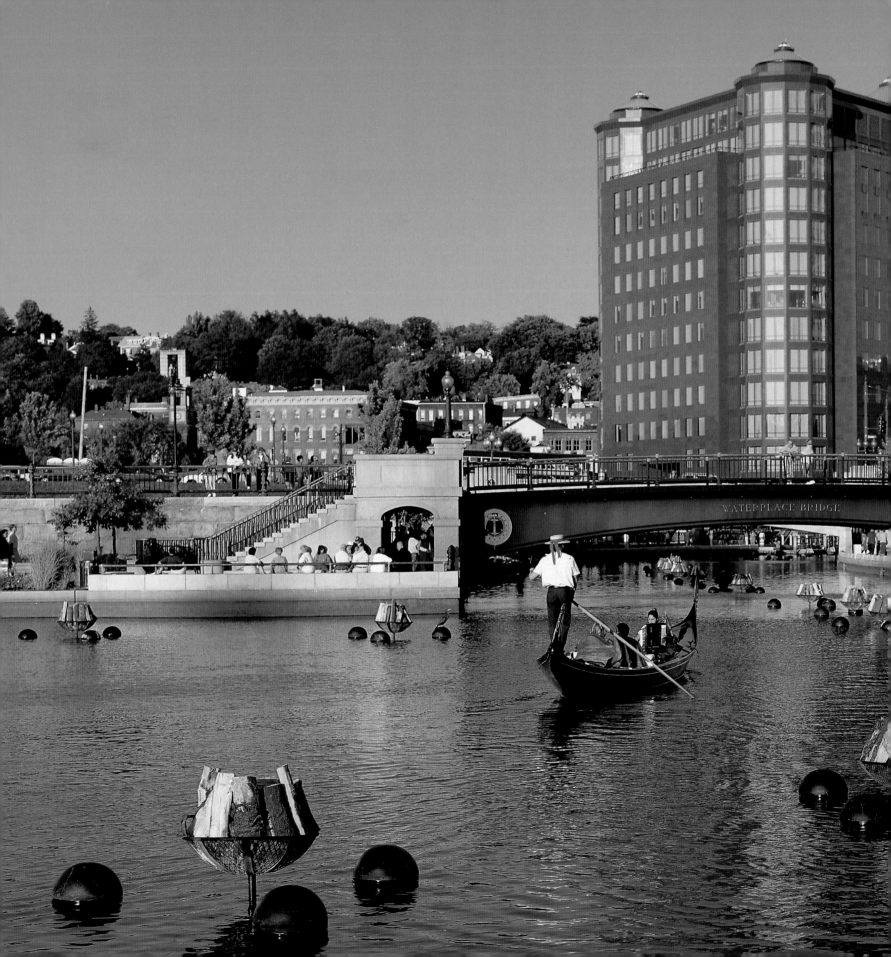

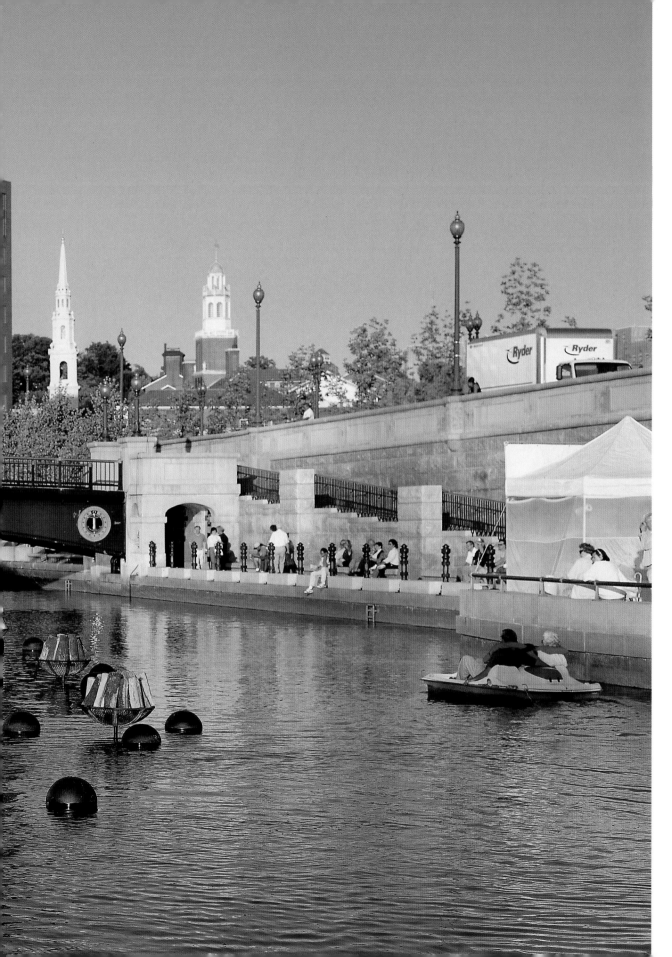

Founder Roger Williams named the capital of Rhode Island in honor of God's providence. Williams formed the first Baptist church in 1638 after being excluded by the Puritans for his "dangerous" opinions.

75

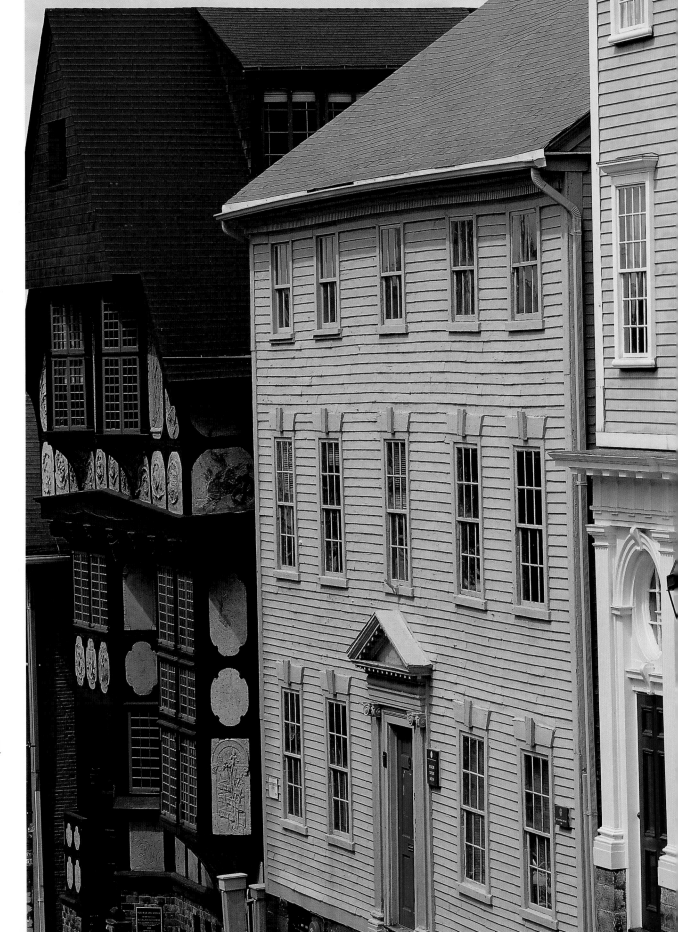

The Providence
Preservation Society
helps care for the
hundreds of historic
homes in the city.
Many privately owned
buildings are opened
to the public several
times a year for tours.

76

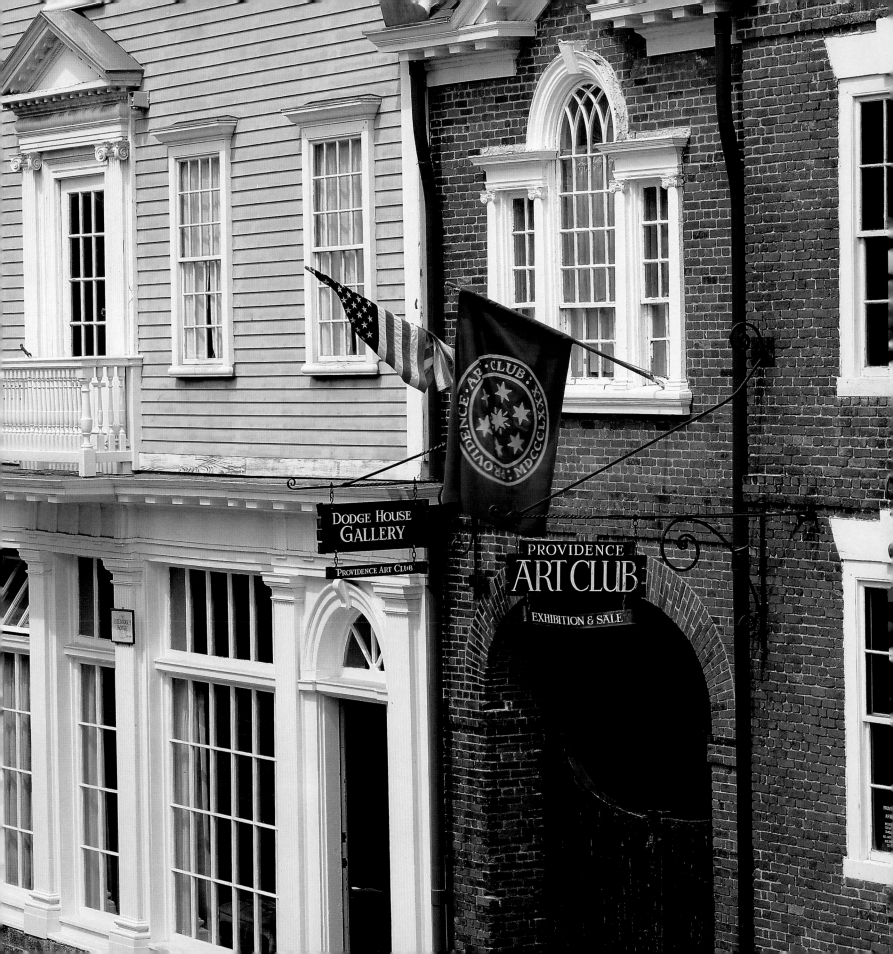

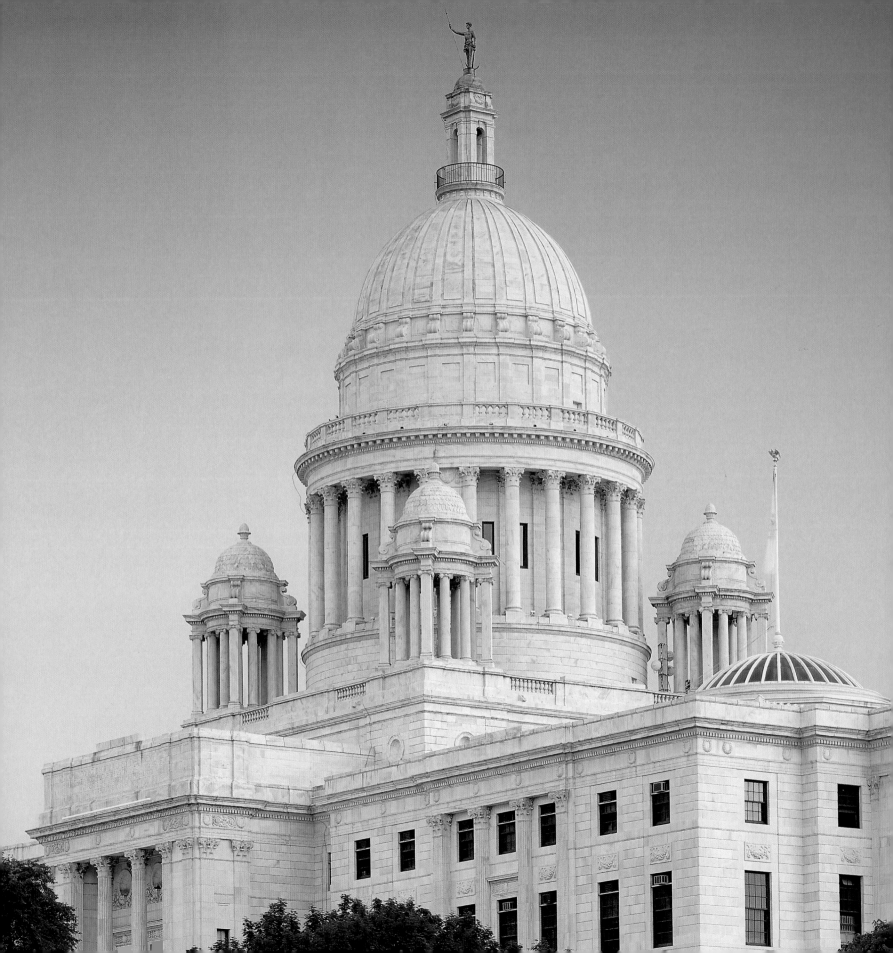

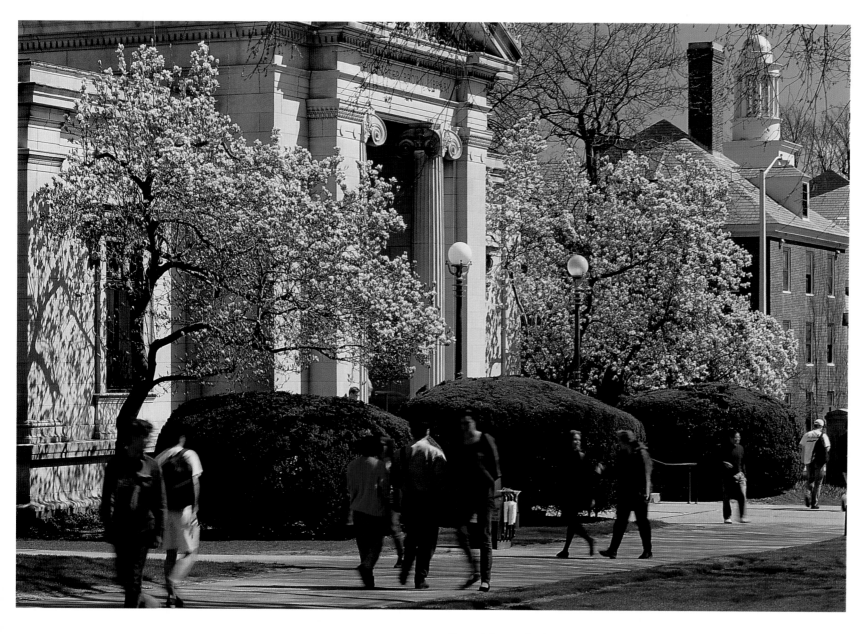

Providence's Brown University was established in 1764. The school is noted for its unique undergraduate curriculum, designed by former president Francis Wayland so that every student "might study what he chose, all that he chose, and nothing but what he chose."

Designed in 1891, Rhode Island's State Capitol boasts one of the world's four self-supported domes. The other three adorn St. Peter's Bascillica, the Taj Mahal, and the Minnesota State Capitol.

A town of just over 20,000 people for most of the year, Bristol draws 10 times that many revelers every July 4th. Fireworks and the oldest parade in the nation are part of the festivities.

OPPOSITE—
One of 12 extravagant mansions under the care of the Preservation Society of Newport County, Marble House was designed by Richard Morris Hunt and built in 1892 for William K. Vanderbilt.

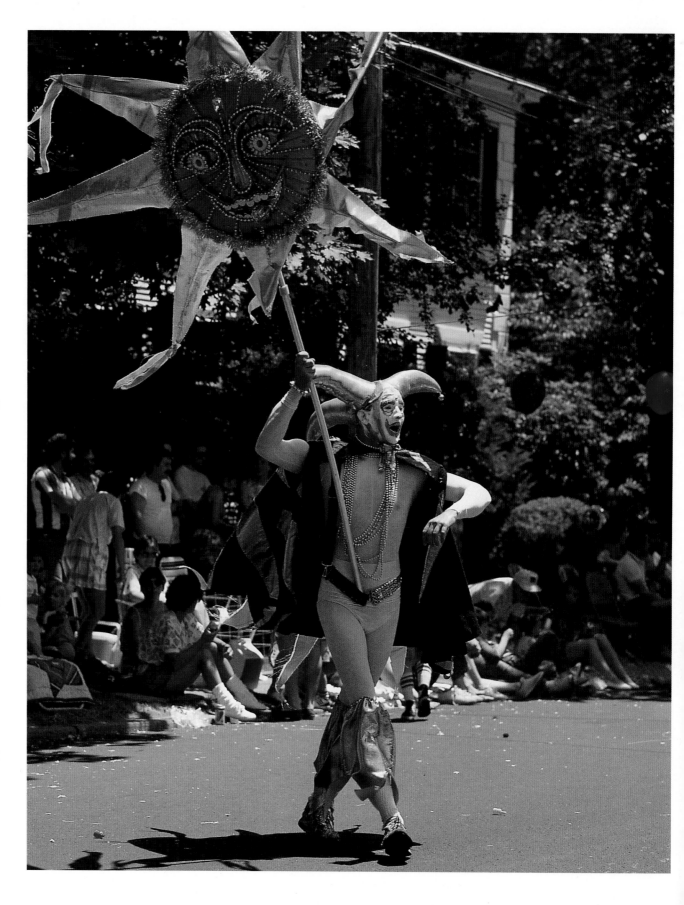

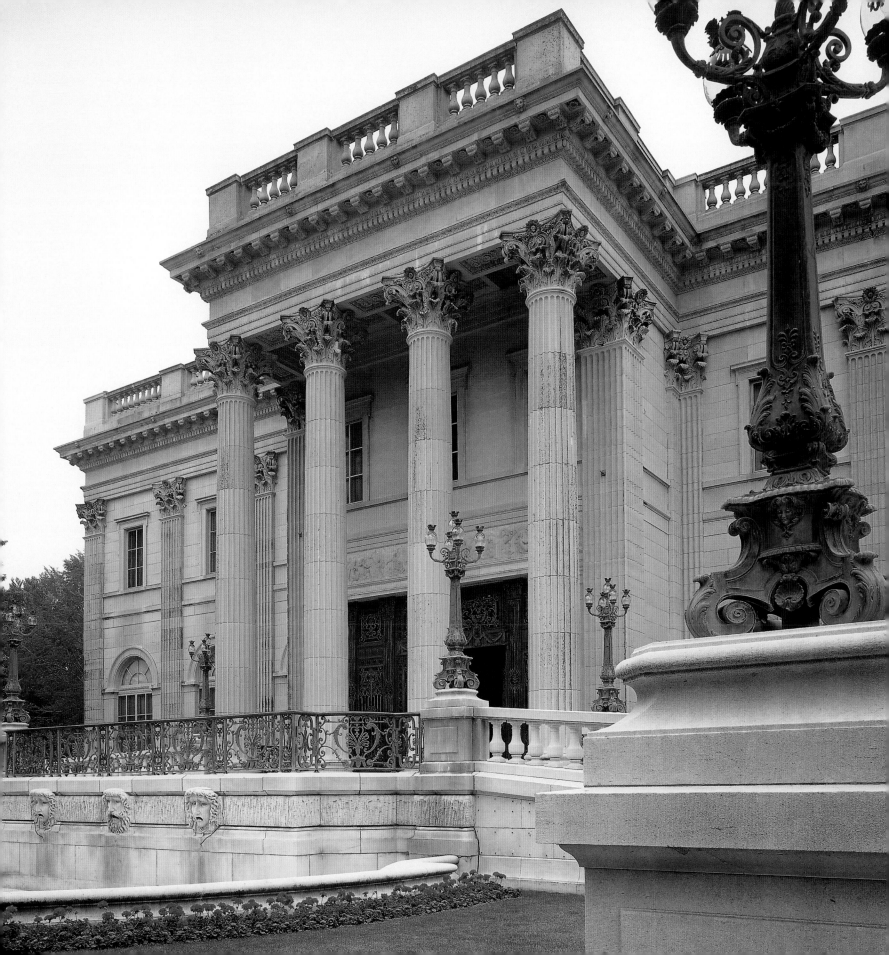

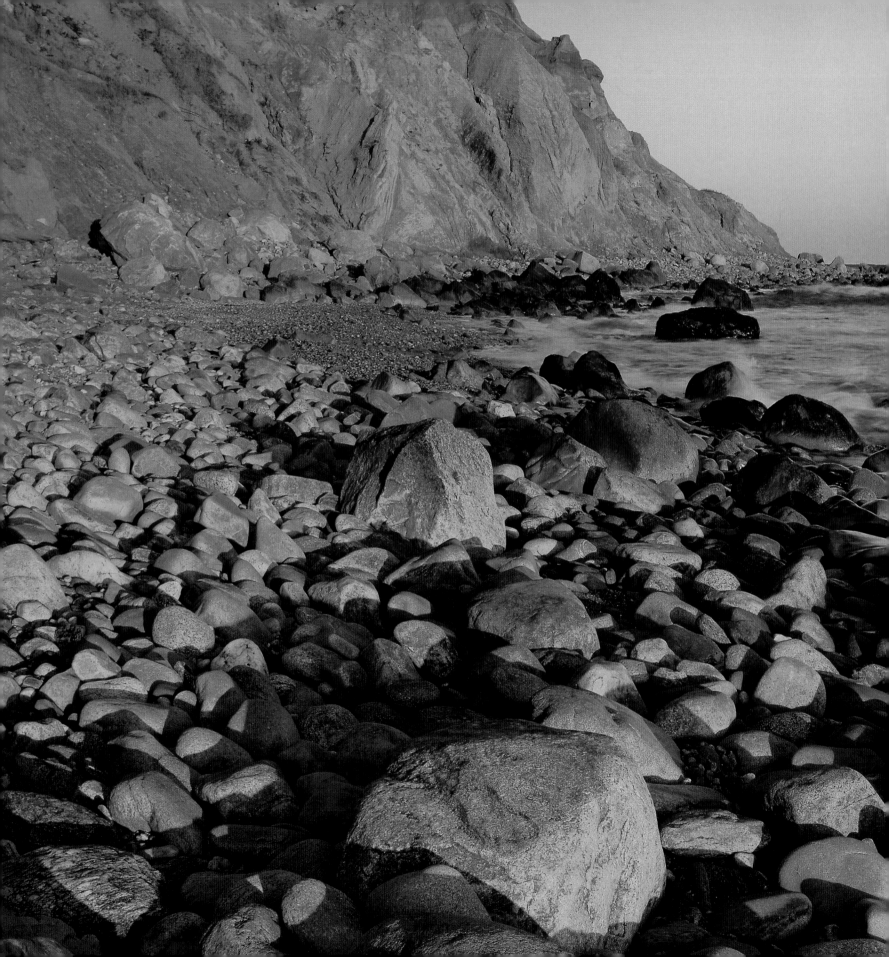

The 200-foot-high Mohegan Bluffs greet visitors to Block Island, 13 miles off Rhode Island's coast. The island manages to balance the charming tourist destination of Old Harbor with the conservation of pristine wetlands, home to more than 150 bird species.

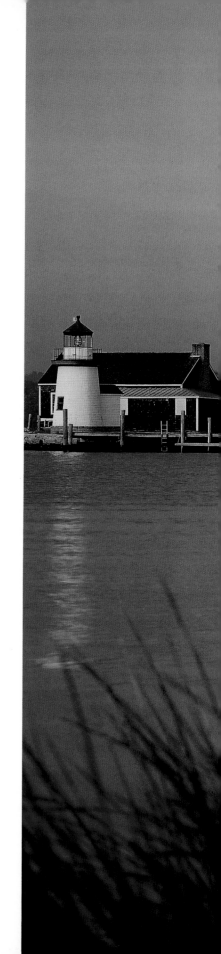

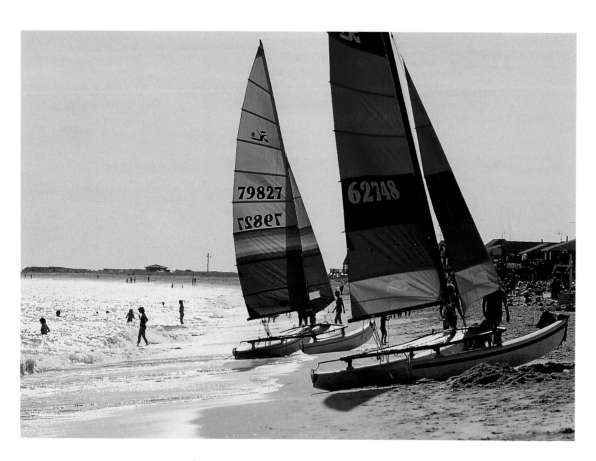

Charlestown's four miles of beaches attract scores of swimmers and boaters. Some of the shoreline, along with Rhode Island's largest saltwater marsh, is protected by the nearby Ninigret National Wildlife Refuge.

Wandering through the Mystic Seaport Museum is like traveling back in time. Along with about 300 vessels, this lively attraction includes a children's museum and the traditional shops of a 19th-century village.

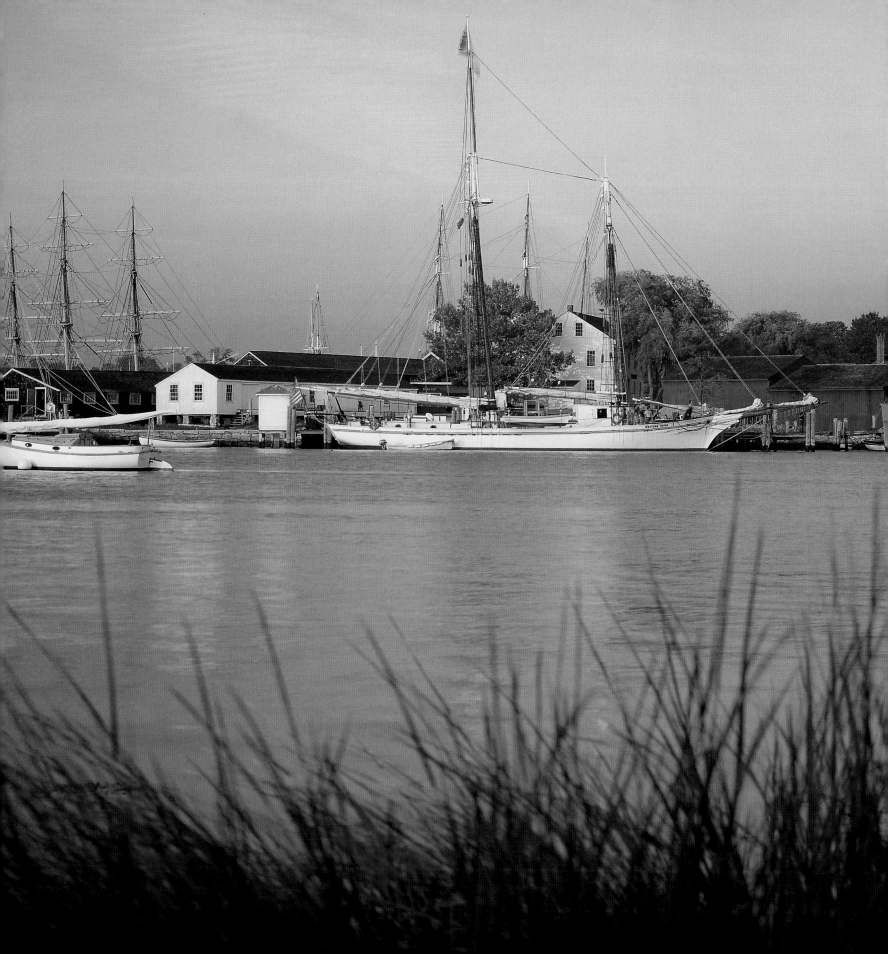

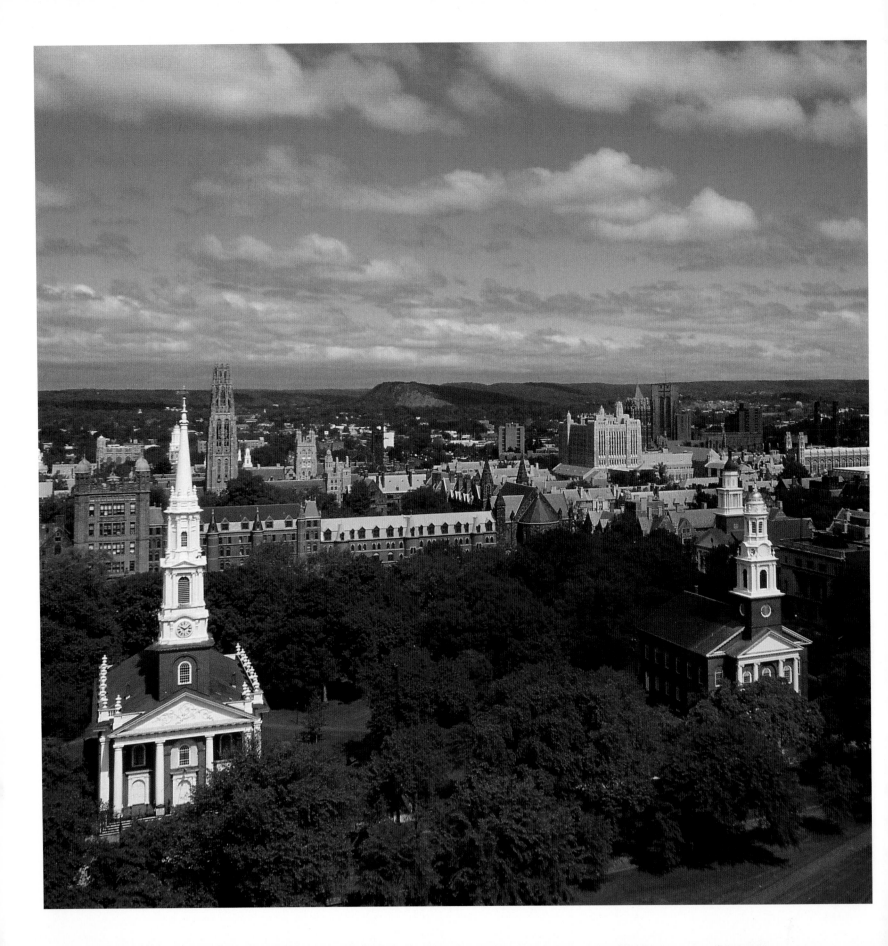

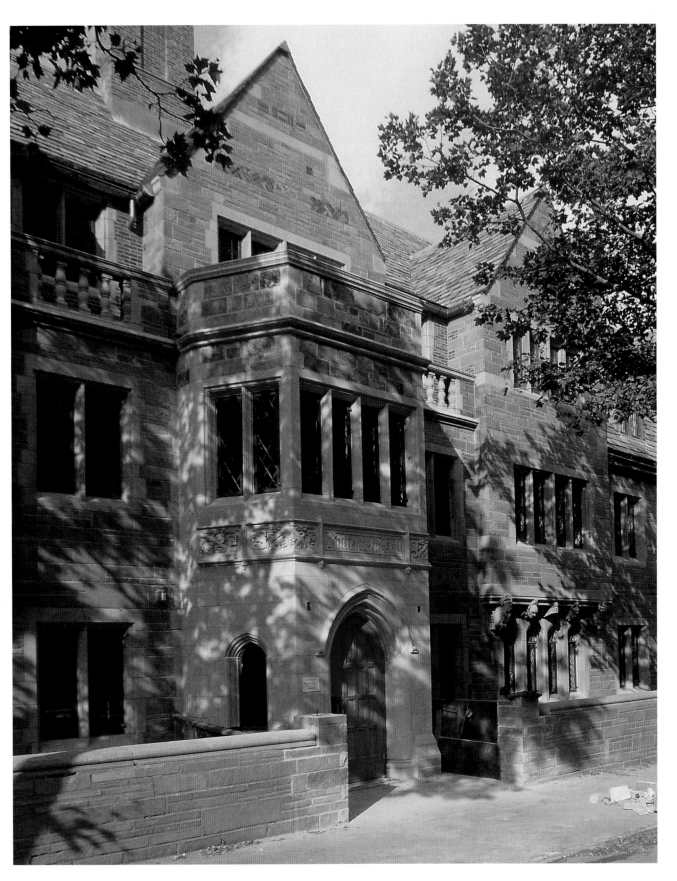

In 1718, trader and philanthropist Elihu Yale endowed his fortune on the school which bears his name. More than 10,000 students attend classes on the 200-acre New Haven campus.

OPPOSITE—
Steeples of three churches grace New Haven Green. The 16-acre square was set aside by village elders in the 1600s and remains the town center.

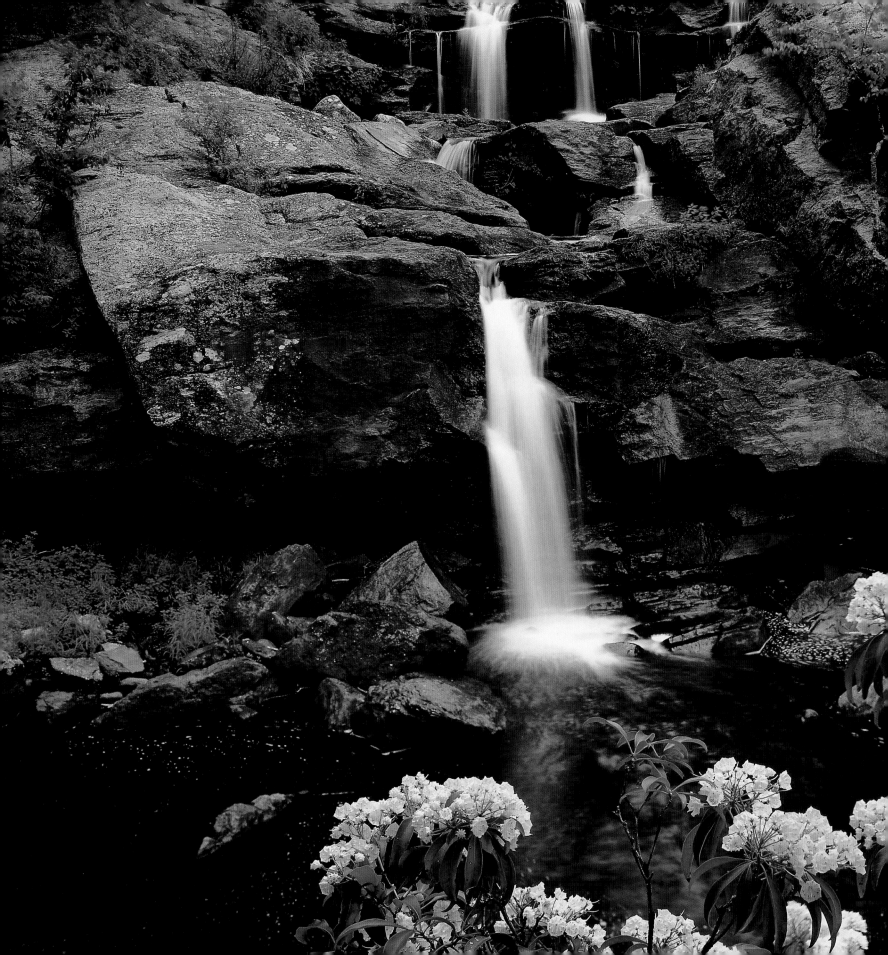

Chapman Falls
tumbles 60 feet into
a bubbling basin in
Devil's Hopyard State
Park in Connecticut.

Writers Mark Twain and Harriet Beecher Stowe are among Hartford's most distinguished former residents.

OPPOSITE— Hartford earned its title as the insurance capital of the world in the 1800s, when companies were formed to protect the shipping interests along the Connecticut River Valley. Dozens of insurance firms remain based in the city.

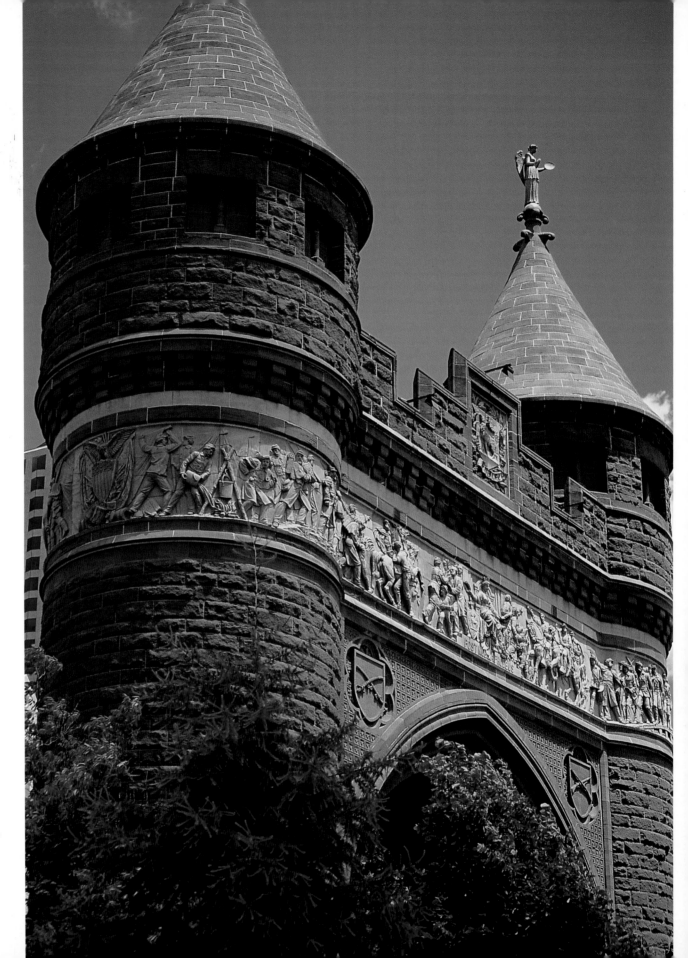

One hundred feet tall and 30 wide, the Soldiers and Sailors Memorial Arch honors those who fought in the Civil War. It stands in Hartford's famous Bushnell Park, which was designed by Frederick Law Olmsted.

OPPOSITE— The country's oldest continuously operating ferry has linked Glastonbury—just 10 miles southeast of Hartford—with Rocky Hill since 1655.

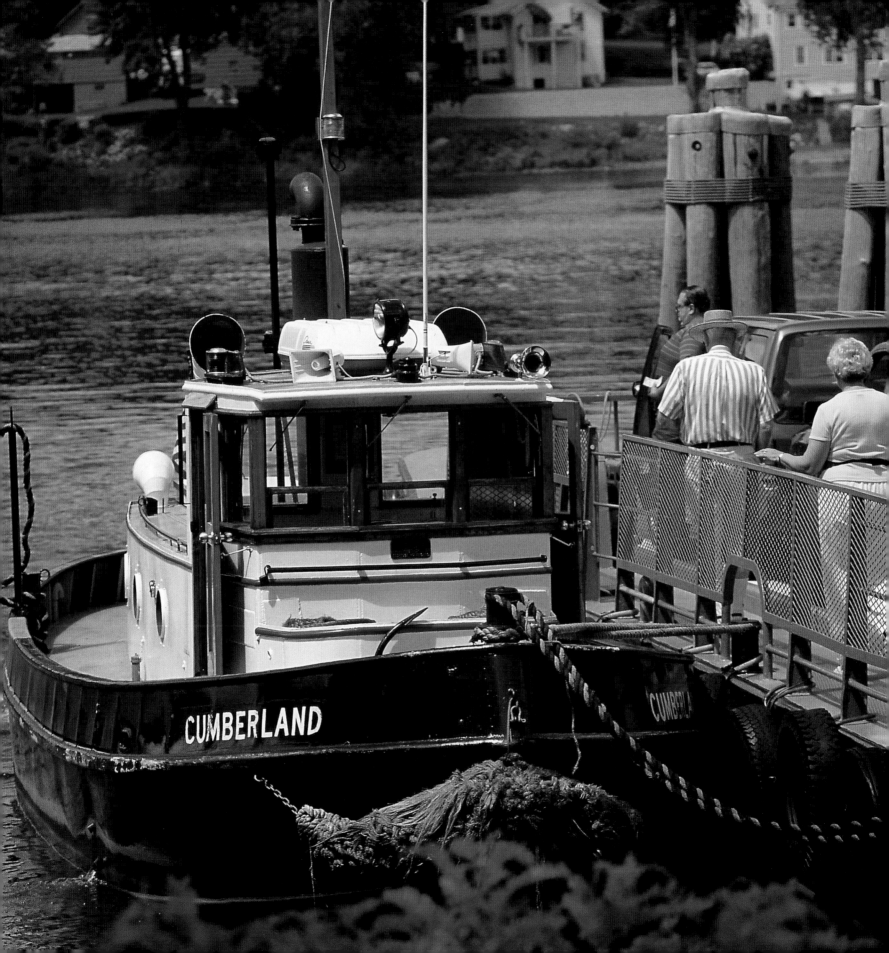

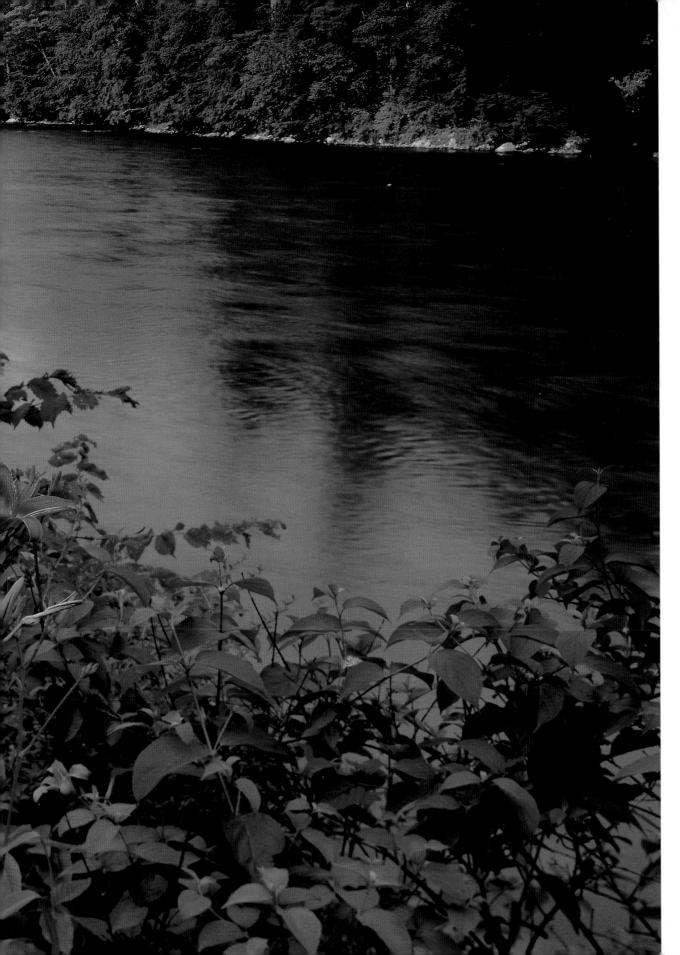

The Housatonic River, a favorite destination for anglers, runs through Bulls Bridge Nature Preserve. Local legend holds that George Washington's horse plunged into the river near here after slipping on a bridge.

Photo Credits

W. Cody/First Light 1, 3

John Shaw/First Light 7

Tom Till 8, 9, 18–19, 21, 40, 45, 54–55, 70–71, 72, 81, 82–83, 88–89, 94–95

Mary Liz Austin 10–11

Oscar Nelder/Voscar 12, 13

Steve Short 14, 42–43

Helen Longest-Saccone/Marty Saccone 15, 26

Irwin R. Barrett/First Light 16–17

Wayne Lynch 20

Jean Heguy/First Light 22–23

Mark Newman/First Light 24, 49

Ulrike Welsch 25, 27, 50, 51, 52–53, 56, 61, 64, 66, 67, 68–69, 80, 84

William H. Johnson/Johnson's Photography 28–29, 30, 31, 34, 35, 36–37, 38–39

M. Manheim/First Light 32–33

Patrick Morrow/First Light 41

Bob Firth/First Light 44

Ron Watts/First Light 46–47

Terry Donnelly 48

Bill Ross/First Light 57, 60, 65

Bill Everitt/First Light 58-59

D & J Heaton/First Light 62–63

Peter Vadnai/First Light 73

Paul Rezendes 74–75, 76–77, 78, 79

Tom Algire/First Light 85

Robert Perron 86, 87

Leslie M. Newman 90, 91, 92, 93